# COALVILLE

## THROUGH TIME

Steve Duckworth, Denis Baker
& John Jacobs

AMBERLEY PUBLISHING

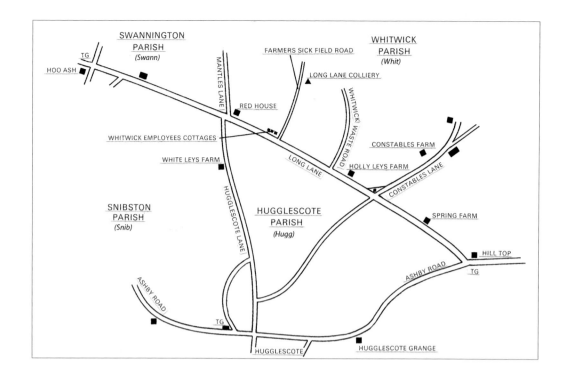

First published 2013

Amberley Publishing
The Hill, Stroud, Gloucestershire, GL5 4EP
www.amberley-books.com

Copyright © Steve Duckworth, Denis Baker
& John Jacobs, 2013

The right of Steve Duckworth, Denis Baker & John Jacobs
to be identified as the Authors of this work has been
asserted in accordance with the Copyrights, Designs and
Patents Act 1988.

ISBN  978 1 4456 1407 6 (print)
ISBN  978 1 4456 1421 2 (ebook)

British Library Cataloguing in Publication Data.
A catalogue record for this book is available from the
British Library.

Typesetting by Amberley Publishing.
Printed in Great Britain.

# Introduction

Unlike many other towns that developed as established settlements in the industrial era, Coalville instead emerged as a separate community, in an area defined by the distant corners of four adjacent parishes: Swannington, Whitwick, Hugglescote and Snibston (*seen in the map on the opposite page*).

Land was suitable for farming and forestry in all the villages except Swannington, where poor quality land had been mined for coal over seven centuries for transportation by packhorses to markets up to 40 miles away. The Lordship of the Manor of Swannington had been purchased in the sixteenth century by William Wyggeston, in order to raise finances to fund a Hospital for the Poor in Leicester from both leases of the minerals and rents from the farms.

Until the beginning of the eighteenth century, mining had been limited to depths of about 150 feet, but Thomas Newcomen's engine was able to remove water from greater depths and eventually provide rotary motion. These engines presented new opportunities to mine deeper coal of a better quality in an area overlaid by later geological deposits.

In the 1820s, William Stenson, a very experienced local engineer, sank a modern, deeper mine in Whitwick parish, gaining access to thicker, higher quality seams. However, he was limited by the cost of transporting coal in bulk to Leicester. George Stephenson, who had successfully developed a steam-powered railway in the Durham Coalfield, was approached, and with others the pair obtained an Act of Parliament in 1830 to build and operate The Leicester & Swannington Railway Company to transport coal from Stenson's Long Lane Colliery.

The four village sectors which eventually formed Coalville were separated by boundary tracks – Mantles Lane and Hugglescote Lane, running north to south, and Long Lane, running west to east. In the

1760s, two turnpike roads had been constructed: the Leicester–Ashby turnpike ran around the south of the district and the Hinckley–Melbourne turnpike to the west of district. Long Lane connected the two turnpikes at Hill Top and Hoo Ash.

The Leicester & Swannington Railway (L&SR) arrived in the embryonic Coalville in 1833, successively crossing the Leicester–Ashby turnpike, Forest Road, Long Lane and Mantles Lane. Railway business was done at station hotels at Bardon, and another near to the central crossroads. A new station on Long Lane was introduced by the Midland Railway Company in 1846 when it took over. Later, in the 1860s, the Charnwood Railway linked with Loughborough and Nuneaton.

While building the railway, the Stephensons and others purchased the coal mining lease for Snibston and sank Snibston Colliery No. 1 in the Whitwick sector, close to Long Lane Colliery, along with their No. 2 in the Snibston Sector and later their No. 3 in the Swannington sector.

Both Stenson and Stephenson introduced up-to-date mining methods, which required the enlistment of an experienced supervisory workforce from outside Leicestershire. Stenson's experts in longwall face working were housed in two rows of cottages, Club Row and Stone Row, named Coalville Place by a local building club. Their workforce travelled from the declining, shallow coalfield at Swannington and Coleorton each day. Snibston Colliery had few local recruits remaining, so they had to recruit miners from all over to learn other special skills and techniques.

The first of the Snibston employees lived in six specially designed rows of houses, built along the Snibston sector of Long Lane. Deputies' Row housed the supervisory staff, while Barrack Row housed single recruits, who moved into other cottages after a trial period. An inn was constructed alongside the Snibston Rows to encourage visitors to stay and do business. Tradition has it that George Stephenson wished to call the new settlement 'New Snibston', but the inn's signwriter incorrectly inscribed 'Snibstone New Inn'.

With two modern mines and a railway locomotive depot operating, it was necessary to attract an engineering facility, and to introduce brick and tile business manufacture, exploiting the local clay deposits. Other service industries attracted blacksmiths, farriers, carpenters, rope makers and speculative housing developers. Coalville's development was contemporary with a number of western towns of America, and was influenced by the same opportunists such as bankers, lawyers, estate developers and general store keepers, many of whom stayed to make their fortunes.

From the beginning, there was a certain amount of animosity from residents of the four villages, whose rates traditionally paid for maintaining the highways, upkeeping the law and supporting the poor. Now local lanes on their boundaries were being ruined by the movement of heavy transport.

The children of the families of the two collieries had free education provided by their schools, which were run on Nonconformist lines, while the rest had to pay for education. As a result, a strong Nonconformist influence developed in the early days of the new community, since the opening of an Anglican church in Coalville was delayed by parish bickering.

A local social reformer, 'George Smith of Coalville', was instrumental in promoting the Brickyard Act in 1877, making it illegal to employ children and young women in the brick- and tile yards. But labourers were quickly absorbed by a thriving elastic web business or shirt and shoe manufacturing. Many brickworks were developed, and wagon builders were also attracted to Coalville requiring housing developments in the Hugglescote and Whitwick sectors. A plethora of small shops developed thar, together with the extensive weekly market, enabled customers to buy almost everything in town by the beginning of the twentieth century.

The local Co-op's rapid successful growth encouraged the development of Coalville until after the Second World War. It could be argued that the arrival of the shopping precinct signalled the beginning of the decline that continued through the closure of two railways by Beeching, which had served the town so well for many years, and mine closure in the 1980s. One of the railways is maintained in a very serviceable condition but there is apparently little or no interest shown by local authorities in reopening a passenger service.

From the 1950s the council has focused its attention on developing new housing on open fields in the Broomleys and Greenhill area, close to the edge of Charnwood Forest. Large estates built by both private and local contractors have grown away from the smoke and noise of industry but sadly we have no photographs of the fields taken before building these houses in a more pleasant environment. Whitwick Colliery has been replaced by a retail park and Snibston Colliery is the location of Snibston Discovery Museum, which attracts thousands of visitors.

The four villages still jealously guard their individuality by active objection to building in the green wedges.

# The Early Days

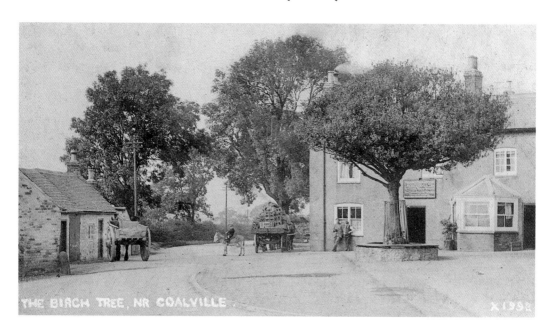

**The Birch Tree Inn,** *c.* **1905**
Prior to Coalville's emergence, the only reasonable transport routes involved the turnpike road system. The Birch Tree Inn stood at the junction of Long Lane with the Leicester–Ashby–Burton turnpike. There was a toll-gate on the turnpike and a toll-bar across Long Lane, which was operated by the toll-house on the left. The inn is now sidelined by major road developments. (*Hugg*)

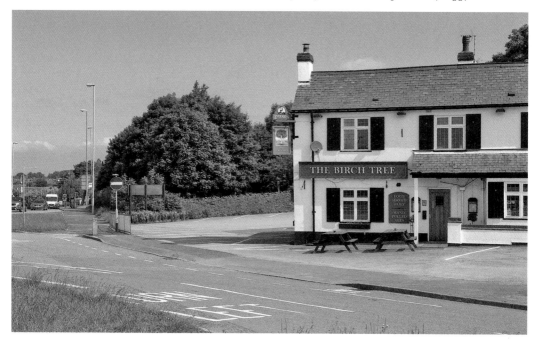

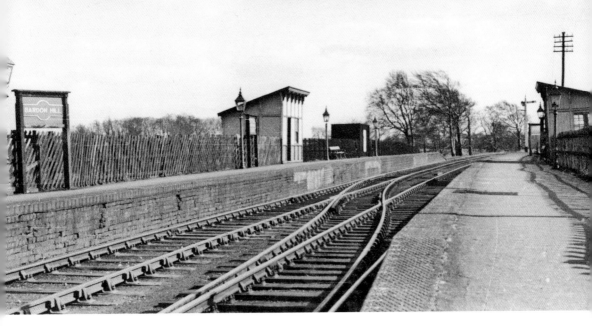

**Bardon Hill Station, *c.* 1930**
Here in 1833, the L&SR crossed the Ashby to Burton turnpike at Ashby Road station, where livery could be hired to visit the hinterland. When the Midland Railway Company took over, it built two platforms with shelters from which it was possible to visit all stations between Leicester and Burton on Trent. The platforms, built with L&SR stone sleeper blocks, were demolished in the 1960s–70s. (*Hugg*)

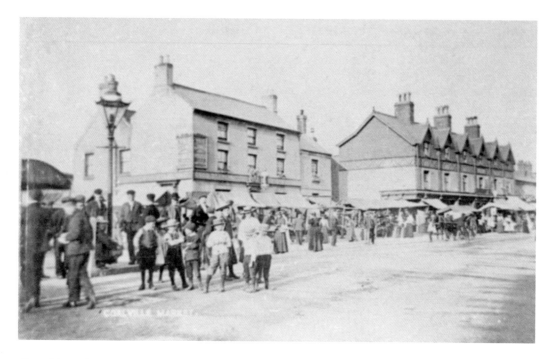

### The Olde Red House and Friday Market

The Olde Red House, at the crossing of Long Lane and Hugglescote, is the oldest surviving building in the town. An early resident of Coalville recorded that it was 'known in more than this county; indeed, anyone even in Derbyshire giving his address as Red House indicated the district from which he hailed'. It was also known locally as 'The Cradle and Coffin'. The market spread on the north side of Station Street as far as the station. The Red House inn is now no longer flourishing, despite its location. (*Whit*)

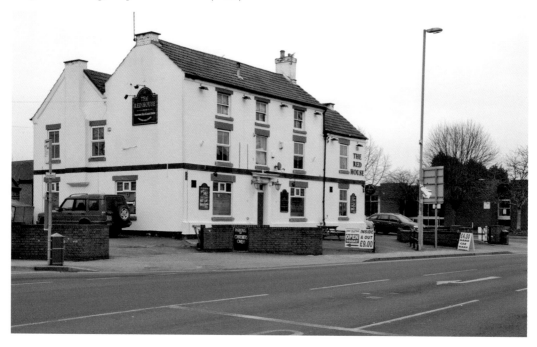

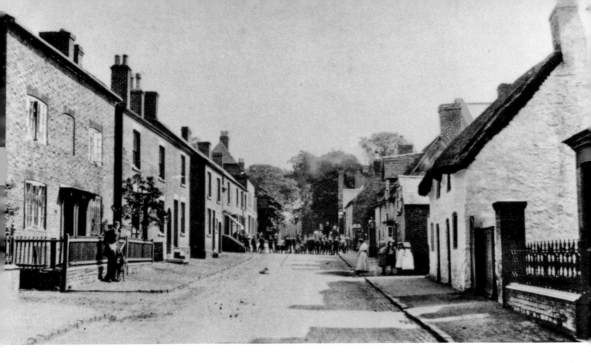

**Hugglescote Village, c. 1895**
The Ashby to Burton turnpike road led through Hugglescote village along a series of ancient roads, one of which was Main Street (later Denis Street), where Glebe Farm and the Baptist church stood. (*Hugg*)

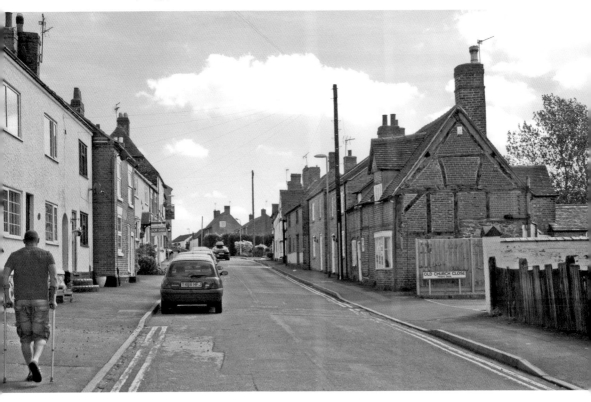

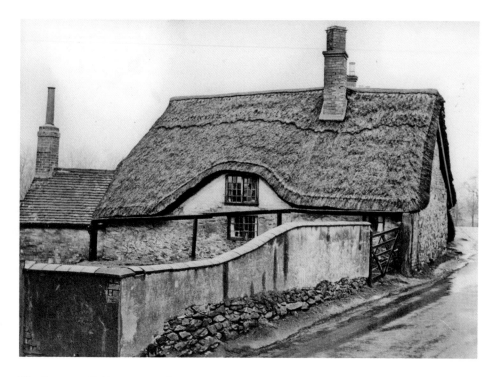

**The Rangers Cottage, *c.* 1946**
Originally part of the ancient manor property, the medieval cottage on The Green survived until 1954, when it was demolished as part of a road improvement scheme. The timber frame was carefully stored by Leicester Museum for future rebuilding on a new site, but it has never been restored. A modern house now fills the space. (*Hugg*)

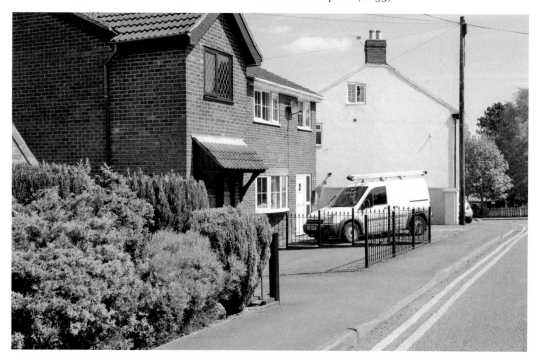

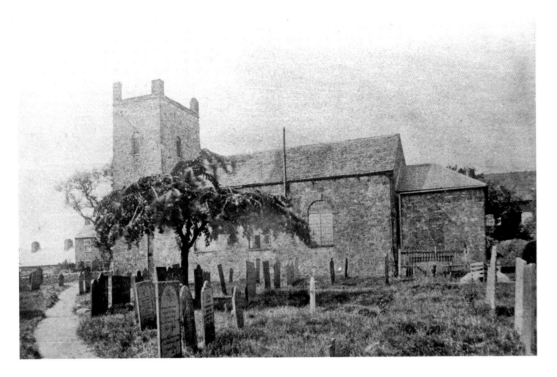

### St James Church

For many years the village was a sub-parish of Ibstock, with a small chapel of ease, St James, dating from the fourteenth century. It was replaced by a larger church in 1776 as a result of village growth. However, in 1784 the tower was struck by lightning, and the structure became increasingly unsafe until 1879, when it was replaced by the present Gothic church of St John the Baptist. All that survives of the old church now is its abandoned graveyard. (*Hugg*)

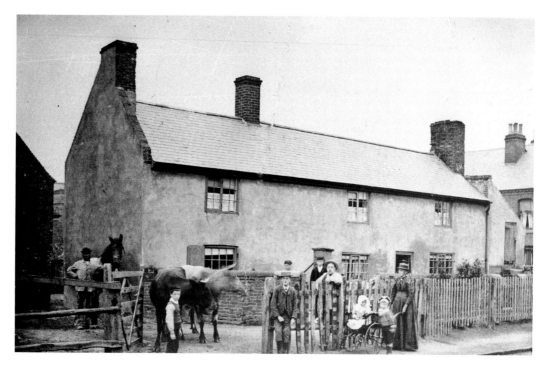

**Whiteleys Farm, *c.* 1890**

The building was one of the earliest in the district, dating from around 1750, when one of its first owners was the Orton family, tanners of Swannington. It gave its name to the surrounding area until around 1900, and survived until the 1950s with a small area of its fields, when most of the land was taken by James Gutteridge for development of his housing estate. The site is now occupied by a poorly-used car park.

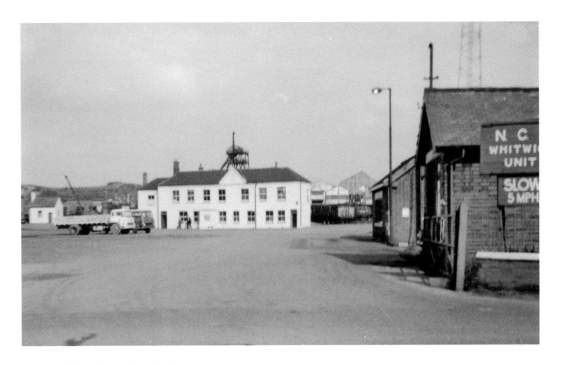

**Whitwick Colliery Offices, 1930s**
As the first colliery to be sunk in the 1820s by Coalville's founder, William Stenson, it later became the Whitwick Colliery. The headstocks of pit numbers three and five can be seen. It had altogether six pits on site, plus extensive brickworks nearby, which were associated with George Smith of Coalville, the Victorian social reformer. These were the offices of the company throughout its life. Here in 1896, a disastrous underground fire resulted in the deaths of thirty-five men. The site of the colliery is now taken by a large retail park. (*Whit*)

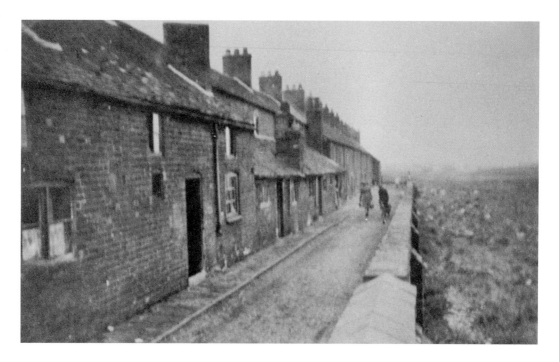

**Club Row, c. 1930**

This row of houses, built by the Coalville Building Club in the early 1830s, housed specialist miners who came from other coalfields to introduce a new way of mining. Called Club Row, it stood at right angles to the road, and was parallel to another named Stone Row to form what later became known as Coalville Place. In 1841, only five of the eighteen houses were occupied by families who were born in Leicestershire. The colliery undermanager lived in the house at the end of the row, which stood opposite the colliery site; adjacent was the Whitwick Colliery brickyard. The whole site has now been developed as an industrial estate. (*Whit*)

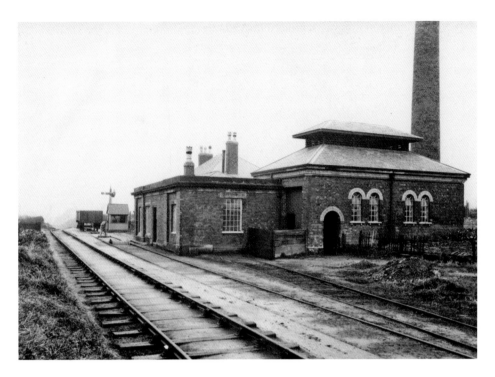

**Swannington Incline Engine House, c. 1926**

The L&SR proceeded on the level through the new settlement, towards its terminus at the foot of a 1 in 17 inclined plane. Coal was hauled up in the early days from Swannington pits by an engine designed by Robert Stephenson. However, a huge pumping engine nearby, installed in 1877, required coal to be lowered from Whitwick until the mid-1940s. The incline is now owned and maintained by Swannington Heritage Trust.

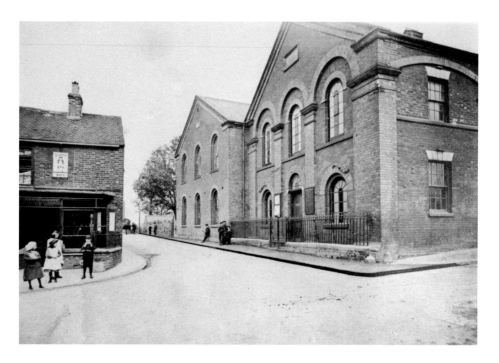

**Chapel Corner, c. 1906**

The large building on the right was the Baptist chapel, built in 1836 to provide a place of worship and education for Whitwick Colliery workers' children. It stood at the junction of Long Lane and Whitwick Road where Onions and White's shop sold fresh fish and groceries. Outside the row of cottages, Whitwick Colliery sank a borehole to provide drinking water for the town's inhabitants. The chapel was demolished when its members moved to a new church in a housing development at the foot of Bardon Hill. The old chapel site was used to widen the road junction and provided future space for the construction of council offices. (*Whit*)

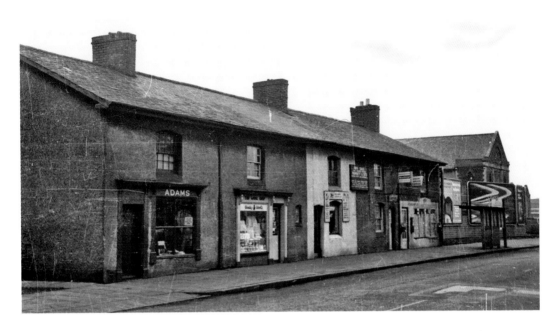

**Barrack Row, *c.* 1955**
This building was among the six rows erected by the Snibston Colliery Company in 1833 as barracks-style temporary accommodation for incoming miners, who were awaiting the construction of other houses before finally settling in the new community. Having settled their original purpose, they were converted into a row of twenty-four back-to-back dwellings and then twelve houses. Eventually, the front rooms of several were used as small convenience shops. The row was initially known as Snibston Row No. 2 and later as Hetton's Row. The Ebenezer Baptist chapel originally held the Snibston Colliery School. The site was later used for the construction of the county police station. (*Snib*)

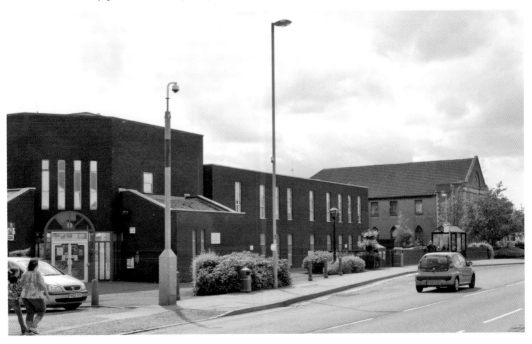

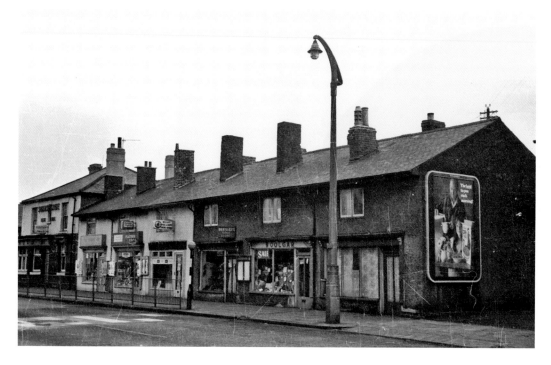

**Deputies' Row and Snibstone New Inn**, *c.* 1955
Originally known as Snibston Row No. 1 and then George's Row or Deputies' Row, these cottages originally housed six supervisory staff members, who had a wash house to allow for a daily bath. Colliers only bathed on Saturday afternoons, so the deputies were expected to display a cleaner, tidier image around town. The front rooms were eventually converted into retail outlets to provide additional income for the family budget. Most of the row and the Snibston New Inn survive. (*Snib*)

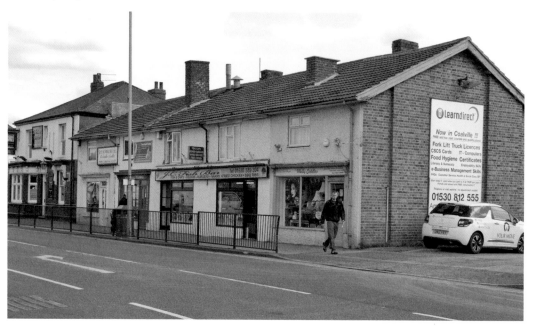

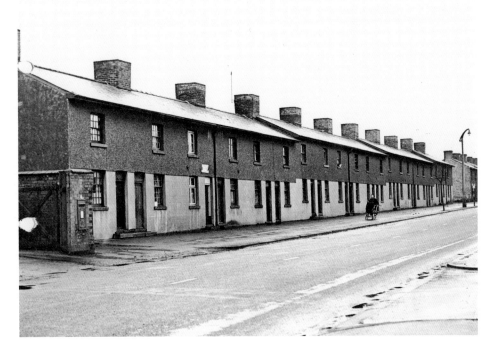

**Snibston Row No. 5**

This row of twenty-one cottages was built in 1833 to house workers from all over the country. The row housed 109 individuals in 1890. Together with Snibston Row No. 6, it was later renamed Snibston Rows West and finally Kimberley Rows. The row was demolished in the 1950s, and one has been rebuilt as part of the Discovery housing development. (*Snib*)

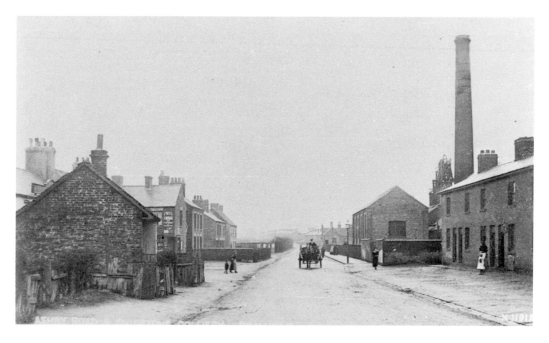

## Ashby Road by Snibston Colliery, *c.* 1900

This view shows Snibston Rows West on the right (*Snib*) and a number of houses on the left (*Swan*), which included two public houses and a beerhouse. These rows were initially occupied by artisans working for the colliery in rope-work, smithying, harness making and tool sharpening. The pubs and beerhouse accepted tokens included as a component in miner's wages by agreement. Three housing estates have recently been built here.

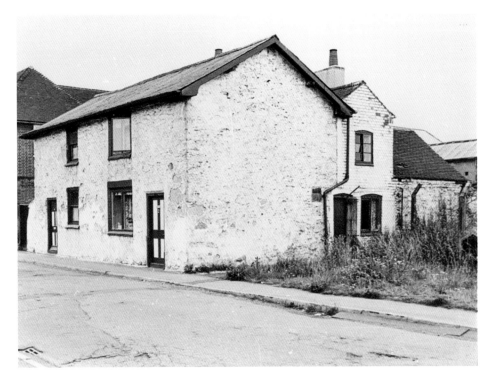

**Mosaic House, Mammoth Street, *c.* 1965**
This was the house of the manager of the Coalville Terracotta and Mosaic tile works. Very well-trained female apprentices were encouraged to produce high-quality goods for markets worldwide, particularly in the state palaces of India. An excellent example can be still seen in the refurbished Tiled Hall in Leeds. The manufacturer at the time was E. Smith. (*Whit*)

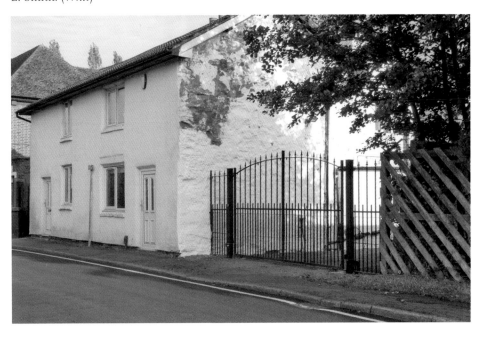

# Development of Station Street
# (Later High Street)

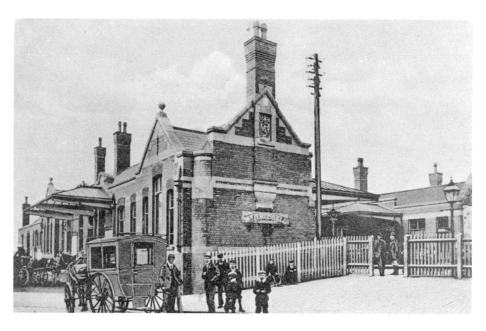

**Coalville Station**

In 1833, when the L&SR passed through Coalville, all business was done from the Railway Hotel, but when the line was taken over by the Midland Railway, a new station was built in 1865. By 1894, trade had improved, and an enlargement was needed to cater for passengers, who by 1904 could travel from Coalville to London on the 11.42 a.m. train in two hours and eighteen minutes. Passenger services ceased to operate from here in 1964 and, despite public pressure, plans to reopen the line have been repeatedly ignored by the local authorities. The site is now a considerable eyesore. (*Whit*)

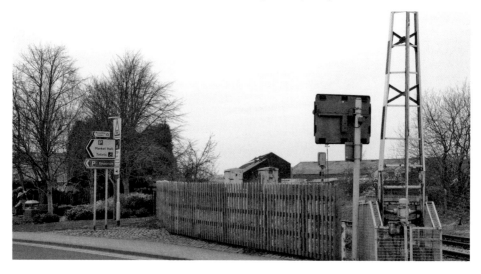

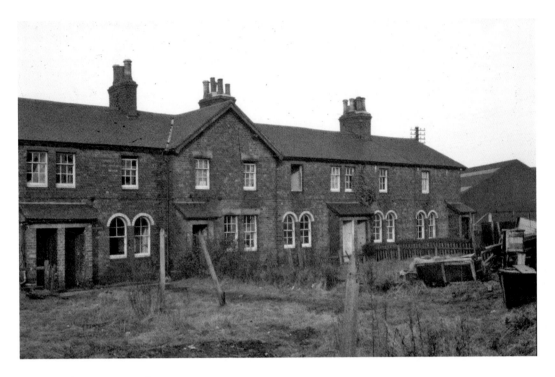

**Station Row, *c.* 1960**
When the Midland Railway Company took over the Leicester and Swannington line it soon began to build locomotive repair works and develop the skills of its workers. Key workers were given accommodation next to the stationmaster's house in houses built to a standardised Midland Railway pattern. The supervisor was allocated the larger dwelling. The row was demolished around 1960. (*Whit*)

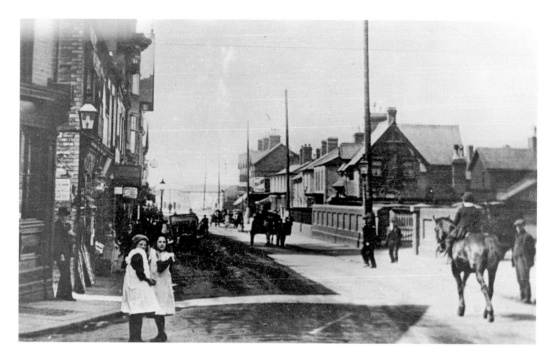

**Station Street, c. 1910**

This picture looking west along Station Street, later renamed High Street, illustrates the successful, rapid development of commerce in the town – bearing in mind the housing on the left (*Hugg*) was developed after 1863 on open fields, part of which were used as a brickyard. On the right (*Whit*) was the station yard, the stationmaster's house and the railway terrace, which accommodated seven families of key Midland Railway workers, three public houses, shops and houses.

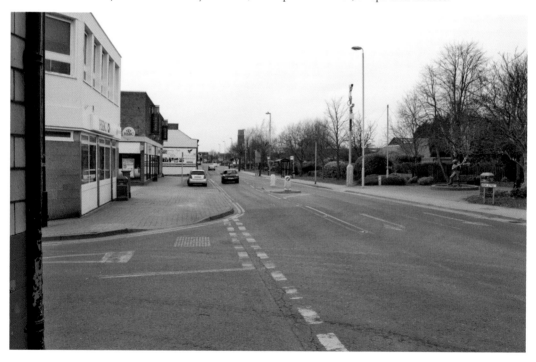

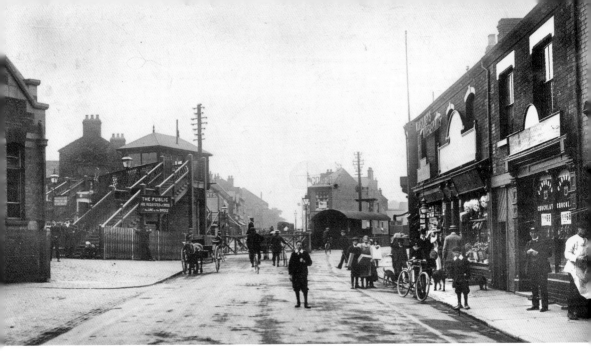

### High Street, c. 1910

The original level crossing of Station Street involved a considerable number of closures, and it was necessary to erect a footbridge in 1851 for pedestrians. A signal box to control the gates and signals was introduced in 1856 at ground level, but the footbridge caused line of sight problems so in 1907 the box was elevated over the bridge. The gatekeeper was killed here in 1856, though his son escaped unharmed despite being caught under the engine firebox.

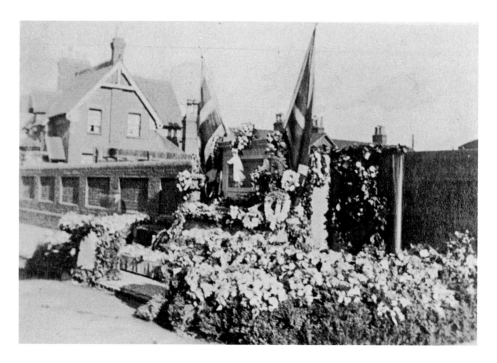

### First World War Memorial Cenotaph, 1920s

We are honoured to be able to include this picture of the first district cenotaph, built into the wall of the station yard on High Street. The stationmaster's house is on the left. The memorial was replaced in 1926 with the erection of the memorial clock tower to commemorate the sacrifice of local soldiers, sailors and airmen during the First World War. A new memorial to the many local miners who lost their lives is now situated near here. (*Whit*)

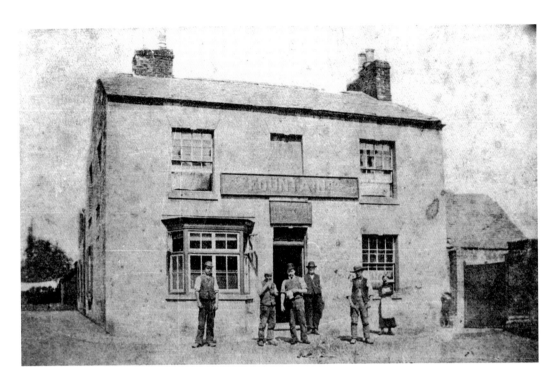

**Fountain Inn, c. 1905**

Next door to the stationmaster's house, and at the end of Station Row, stood the Fountain Inn, which was built in the early 1840s and managed for several years by James and Amy Smith. The photograph evokes images of the American West, and also includes a 60 per cent image of a little boy, who had cleverly appeared and disappeared while the photographer was under his dark cloth. A day centre is sited here today. (*Whit*)

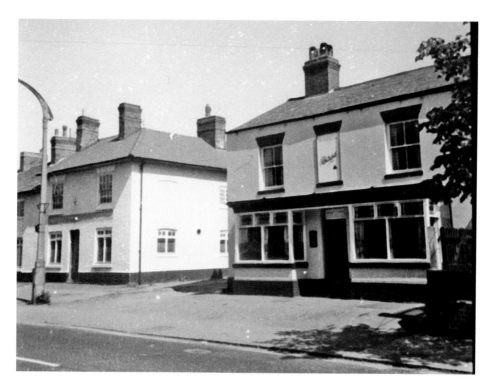

**Fountain and Blue Bell Inns, c. 1956**

The north side of Station Street was one of the earliest to be developed by property speculators, and included these public houses. Behind the Bell Inn, later known as the Blue Bell, a military gentleman built Marshall's Row, a row of thirteen cottages at right angles to the road. Parallel to this was Station Row, a further row of seven cottages built in 1846 by the Midland Railway Company behind the Fountain Inn. These properties were about to be demolished when photographed. The site is now occupied by the public library and day centre. (*Whit*)

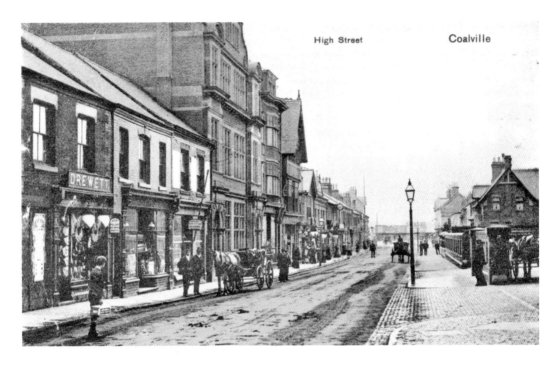

### High Street, 1905

The building on the left of the south side of High Street, originally called Station Street, began on open fields that were bequeathed in 1863 to some of William Stenson's family. They erected long terraces of houses for the growing population. Some of the occupants began to convert the front rooms into shops, providing a comprehensive range of goods and services, including tobacco, wines, medicines, haberdashery, jewellery and watches, bespoke tailoring, boots and shoes, groceries, hardware, millinery and toys. All the buildings on the left as far as the projecting clock were demolished when the precinct was created. (*Hugg*)

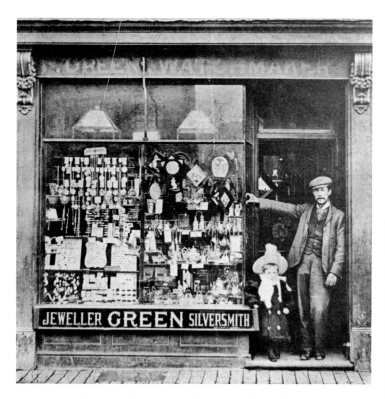

**Fred Green, Jeweller, c. 1900**
Like many local men, Fred Green had the foresight in the 1880s to cater for working-class customers by organising an instalment scheme. Prospective customers contributed weekly amounts of a shilling or sixpence to his watch, clock or jewellery club until they had the necessary funds to purchase, for example, a quality watch, with a two year guarantee, for 30 shillings. He was quickly able to set up two further branches in town. The shop now provides a dry-cleaning service. (*Hugg*)

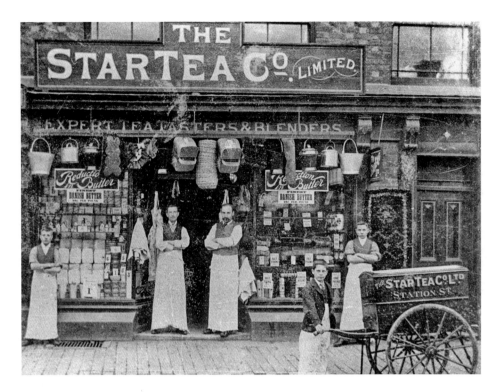

**The Star Tea Company, *c.* 1910**

This branch of the one of the largest grocery retailers in the country arrived on Station Street in the 1880s, advertising, 'Groceries of every description of the very best quality, at prices never before attempted or heard of in Coalville'. They specialised in the 'Finest teas in the world at 2/6*d*; best Danish butter at 1*s* a lb; Pure Demerara Sugar at 2*d* for 2lbs; Valencia raisins at 3*d* a lb and Choice Salmon at 5½*d* a tin'. Parcels could also be delivered to your home. The shop closed with many others in the 1960s, but is now occupied by a community advice centre. (*Hugg*)

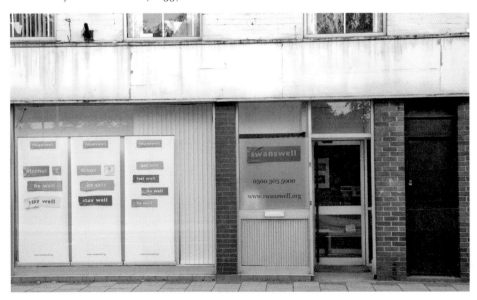

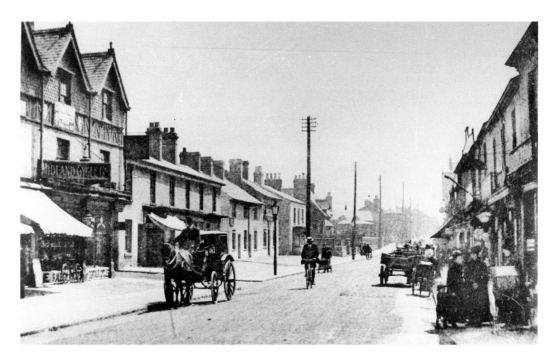

### High Street, Looking East, *c.* 1910

By this time, the front rooms of the majority of the houses on the south side (*Hugg*) had been converted into shops, from which it was possible to buy most necessities. Some of the shops on the extreme left (*Whit*) had a third floor added to provide better living accommodation for families. The wide pavement on the north side provided standing for the Friday market that stretched from the centre to the station. All the buildings shown on the left were later demolished to make way for the new library and day centre.

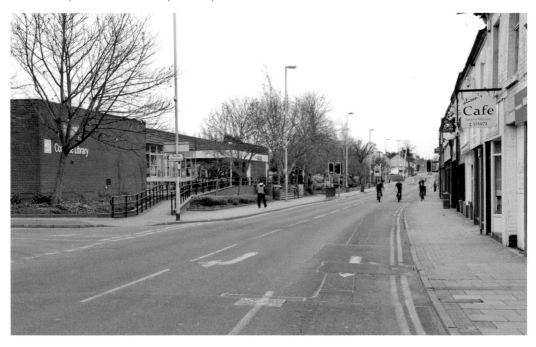

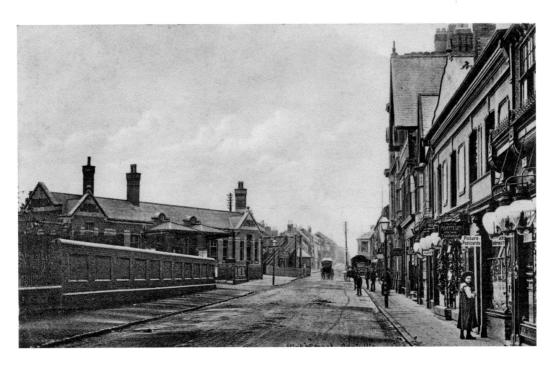

**High Street Looking East, *c.* 1918**

By this time the shopping provision was fully developed, and it was claimed that it was possible to buy any commodity you wished without leaving town. The attempt to convert High Street properties to triple-storey buildings was halted by the war, and the station was very busy. The Leicestershire Bank was a prominent feature of the High Street until modern developments caused its demise.

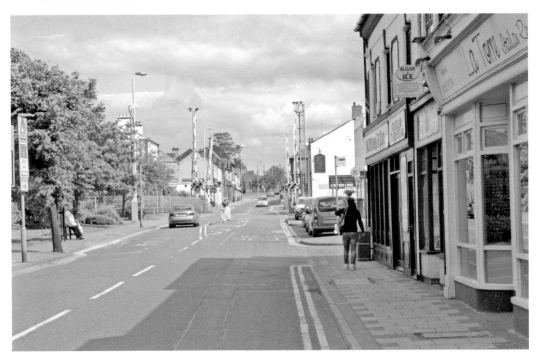

# Development of the Old Market & Ashby Road

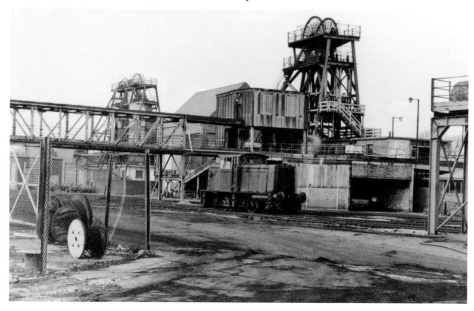

**The Branch Railway to Snibston Colliery, c. 1925**
In 1833, a branch railway was installed to take the output of the colliery to the L&SR. It passed to the south of the Snibston Rows and crossed Hugglescote Lane, at a level crossing known later as Oliver's Crossing. This and the crossing on Station Street caused long delays to road transport for most of Coalville's history. The loading gantry, which allowed coal to be loaded rapidly into wagons by gravity, had only recently been installed. This feature survives in the Snibston Discovery Museum. (*Snib*)

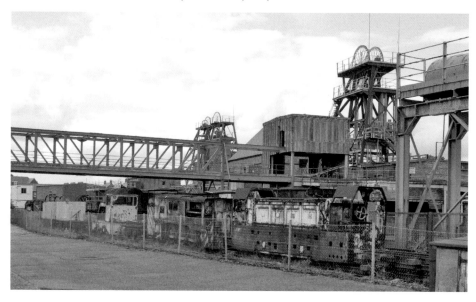

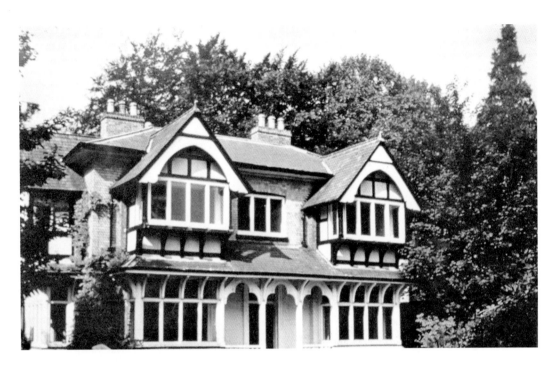

**Snibston Grange, *c.* 1948**
The old Grange building was modernised in around 1840 to house the family of George Vaughan, the manager of the colliery. It was he who arranged the refurbishment into a luxurious house, which he occupied until he retired from Coalville in around 1880. There followed a number of other occupants, until it was abandoned due to mining subsidence damage and was eventually demolished. (*Snib*)

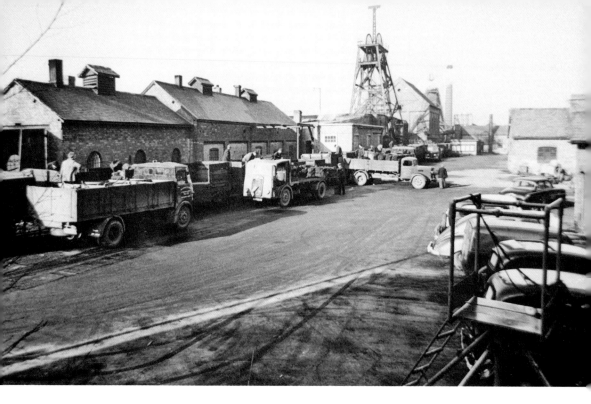

## Land Sales at Snibston Colliery, 1960

Coal was obtained from here by local coal sellers or fuel distribution companies, and was delivered to local industries and used for domestic use. By this time it was no longer acceptable to tip domestic coal into the highway to be barrowed in by householders. The site is still identifiable in the museum. (*Snib*)

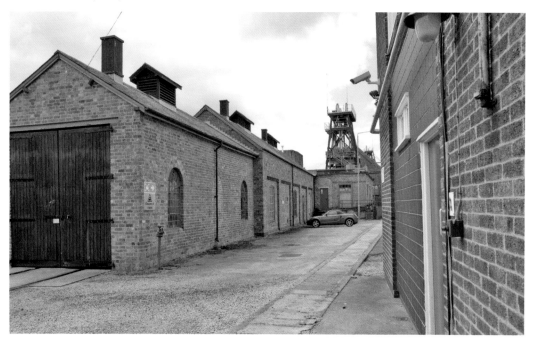

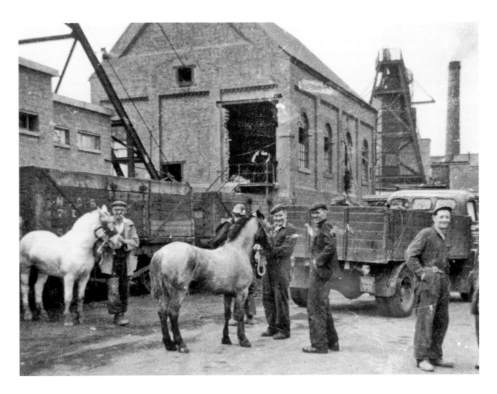

**Pit Ponies on Holiday, c. 1950**
Pit ponies were still being used for some underground duties at this time, but it had by then become practice to remove them to the surface for an open-air holiday in the fields during the summer holiday period. Each of the ponies had its own characteristic behaviour underground, and the bond between miners and the ponies was well known. (*Snib*)

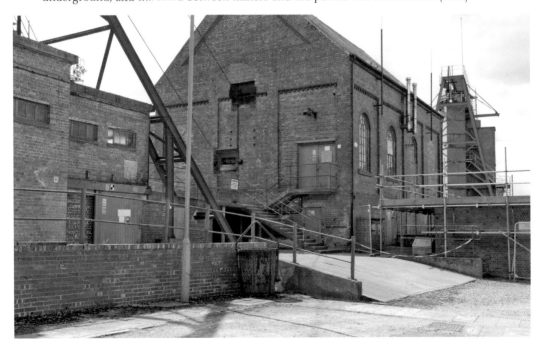

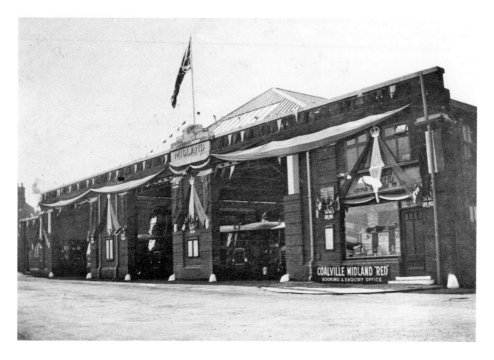

### Midland Red Bus Garage, 1937

The Midland Red began operations here in 1921 as one of a number of bus companies, based either in town or in surrounding villages, which catered for the local population. By 1925, many of the others were taken over by the Midland Red Company, who demolished both Snibston Row No. 4 (Short Row) and James Place, a house which had been occupied by George Stephenson's brother James to build their garage. Fifty of their buses could be looked after in this garage, which was dressed up for the coronation. Bus operations have now finished, and the site has been up for sale for several years. (*Snib*)

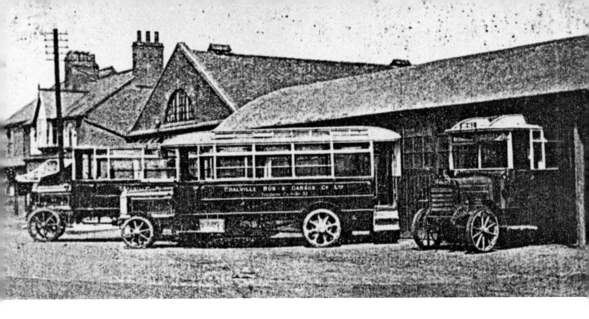

### Coalville Bus & Garage

This business on the north side of Long Lane was started in 1910 by a group including Coleman Brothers to enable people from surrounding villages to trade in Coalville. Their first vehicles, initially open-top Fiats, were stationed in this garage, which provided a retail outlet for petrol. They invited customers to 'Travel by buses belonging to your own district and patronise local industry'. (*Swan*)

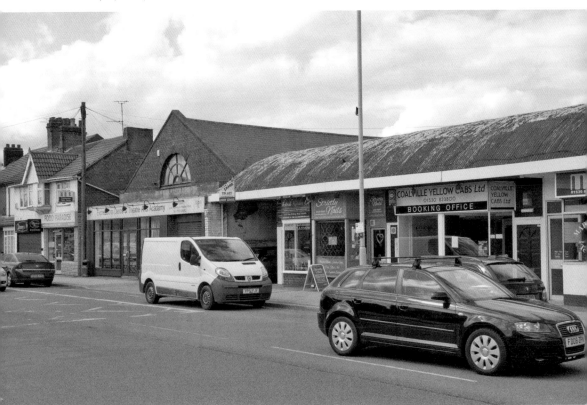

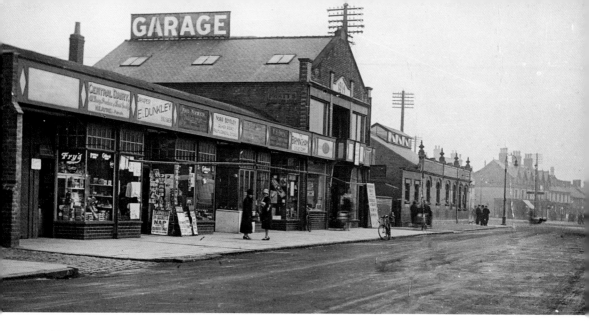

## Ashby Road Shops and Bus Garage, *c.* 1930

In 1906, an attempt was made to construct a 'Castle Theatre' on Ashby Road, temporarily built of wood and corrugated iron, but permission was refused when opposed by local churches. The building was taken over in 1914 by Coleman & Sons for use as a garage for their vehicles of the Coalville Bus Company and a retail outlet for petrol. They claimed: 'We issue times to run – others run on our times'. They also had a taxi hire business. The garage building was destroyed by fire in the 1970s, but the tin-roofed shops continue to be occupied. (*Swan*)

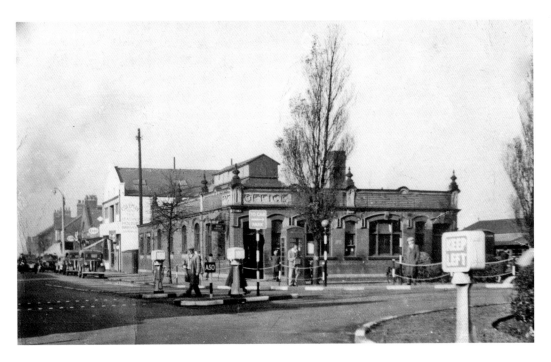

### The Post Office, *c.* 1955

As the town developed, postal services were provided from the shop of Mr Hewes, opposite the station. As demand grew, the post office was moved to larger shop premises near the centre crossroads. A further move in 1904 into a new post office on Hotel Street proved inadequate to provide the regular service requirement of three deliveries and collections a day, which was only achieved with the building of the Gothic-style post office at the centre. The new development was completed in 1960. Various attempts have since been made to deal with traffic management at the junction. (*Swan*)

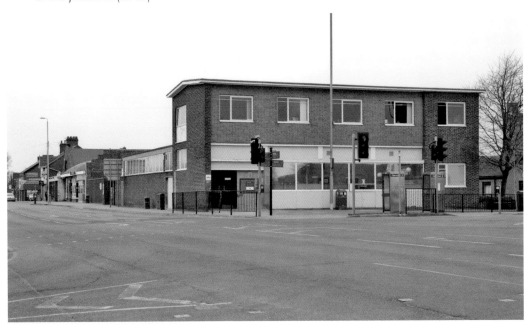

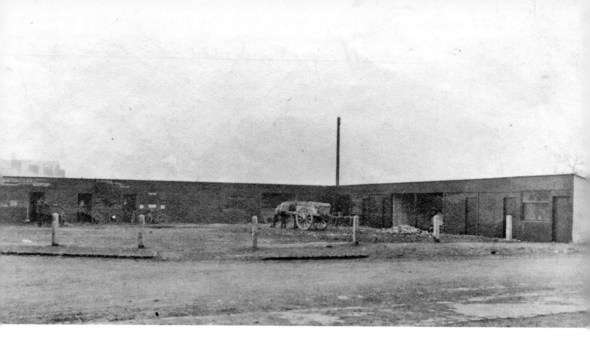

## Coalville Market Sheds

In 1909, it was reported that the old wooden buildings used as a shambles, which had been an eyesore for years, were sold by auction and raised thirty-one shillings. It was agreed that new temporary buildings, erected in their place by Wyggeston Hospital Trustees, looked better. The new market proved to be a great attraction, even to people from Leicester! A health centre now occupies the site. (*Swan*)

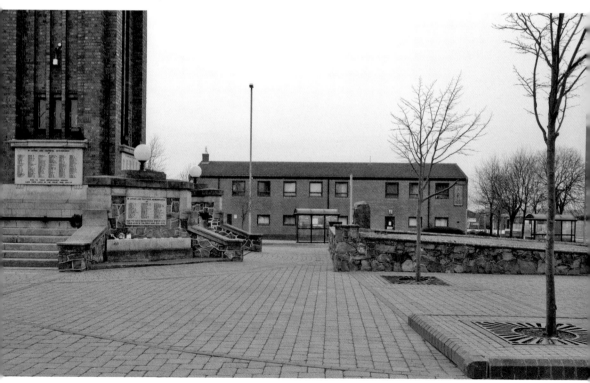

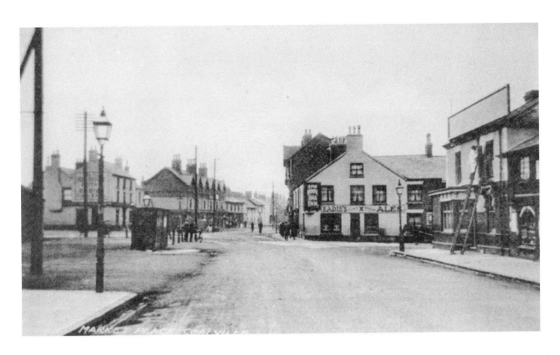

### The Green Man, 1925

Much of the Swannington parish land was owned by the medieval Wyggeston Hospital Trust. From 1879, the area, commonly called 'the dump', attracted a large weekend market and contained a cast-iron urinal for the relief of male customers from around ten public houses! It was fabricated by the local engineering works, and always had a bicycle propped up outside. Tradition says it belonged to a foreman of the wagon works, and was welded to the structure as a jape by his apprentices. The urinal was demolished to provide space for the war memorial. Two of the pubs have been abandoned for several years in an appalling state, both inside and out, and the Red House has barely survived. (*Swan*)

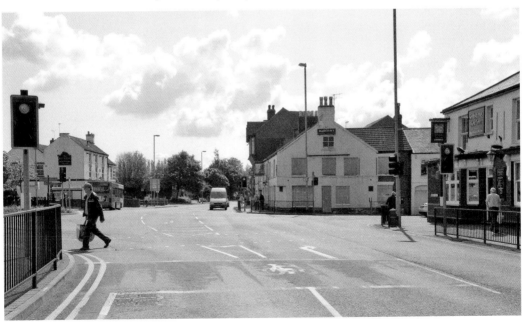

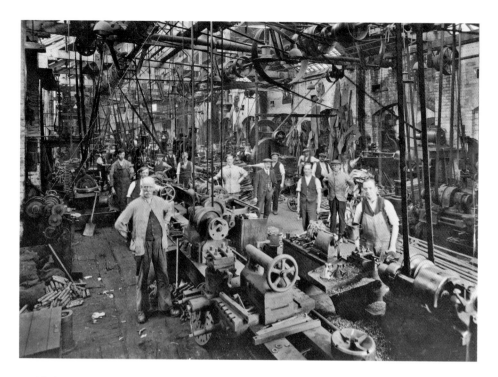

### Stableford's Wagon Works, c. 1910

J. W. Stableford set up an engineering works in 1865 for the repair and fabrication of railway wagons. He passed over control to W. D. Stableford, who enlarged the works in 1884 in order to make wagons for the developing crude oil industry and for the Indian State Railway. A workforce of 1,000 workers was employed in around 1910, including many recruited from the Black Country, to produce heavy chains, wagons, steel fabrications and brass and iron castings. The large building provides a location for 'starter businesses' under the name Springboard. (*Whit*)

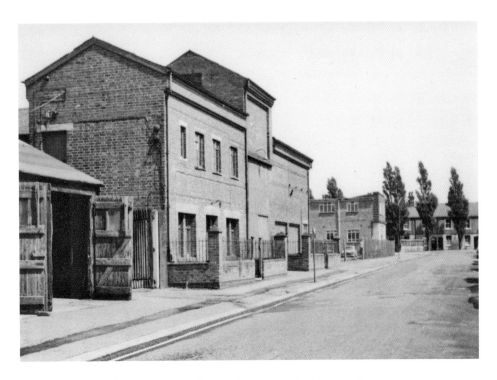

**Leicestershire and Warwickshire Power Company, Market Street**
In 1922, the first rumours of electricity's imminent arrival were circulating and small local pressure groups were emerging to ensure they had access to it. Extensive plans were being laid to develop the installation from the Coalville substation, and the lights were switched on in Coalville on 3 October 1926. (*Swan*)

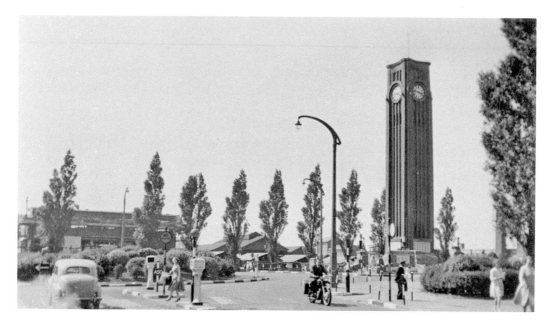

### The Memorial Clock Tower *c.* 1960

The clock tower was built in brick and stone as a fitting memorial for the 354 men of the district who gave their lives in the First World War. The sixty-eight-foot tower was erected by a local builder and his son, and was unveiled on 31 October 1925 by social reformer Charles Booth in the presence of 10,000 people. The memorial was enlarged in 1950 to include the names of those men who died in the Second World War. All the names are recorded in lead, affixed to Cornish granite slabs. The whole community regards Memorial Square with pride but, despite part pedestrianisation, it is sadly dominated by traffic flow. Many people would prefer the open market to return here. (*Swan*)

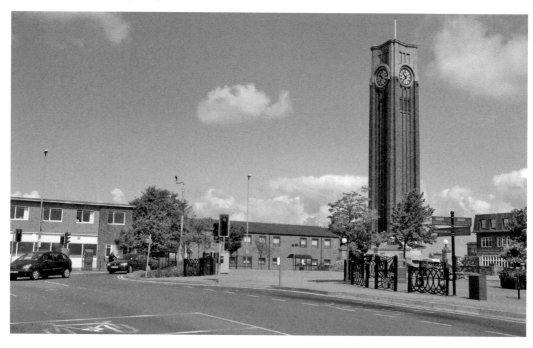

# The Development of Hotel Street
# & London Road

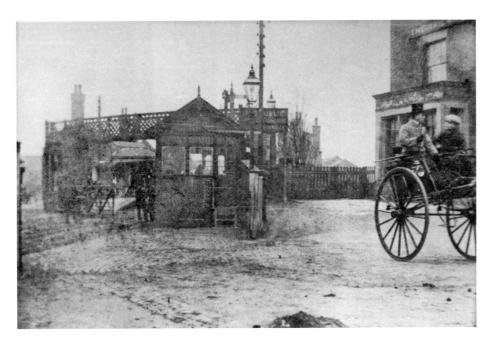

**Midland Railways Signal Box on Hotel Street, 1906**
The railway crossing over Hotel and Station Street required the signal man to control the gate opening and signal operation. Considerable rail traffic caused many pedestrian and vehicle delays so the box was raised to improve operation. It was removed in the 1980s to the Discovery Museum and the crossing is now controlled by remote camera.

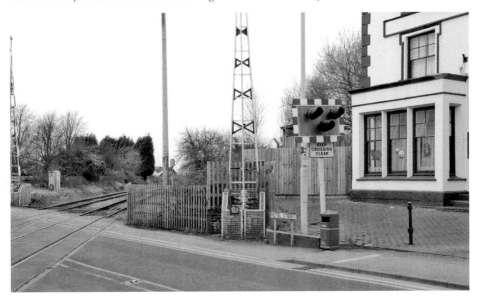

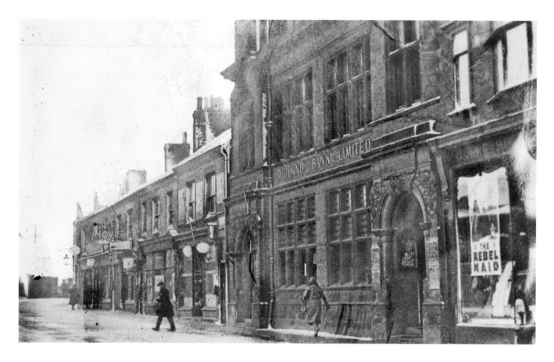

**The Leicester Banking Company, 1920**

Prior to the opening of this bank, the traders in Coalville had to visit Ashby to carry out their financial arrangements. Their first bank opened in a small front room sub office on High Street for one day a week, increasing to two days in 1886. Full-time banking was introduced in 1892, when this building was erected at a cost of £3,000. The upper floors were used by the Coalville Council and accessed by a side staircase. The bank was taken over by the Midland Bank, and later demolished as part of the construction of the new shopping precinct. (*Hugg*)

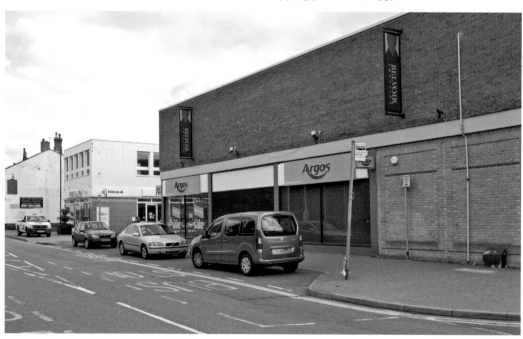

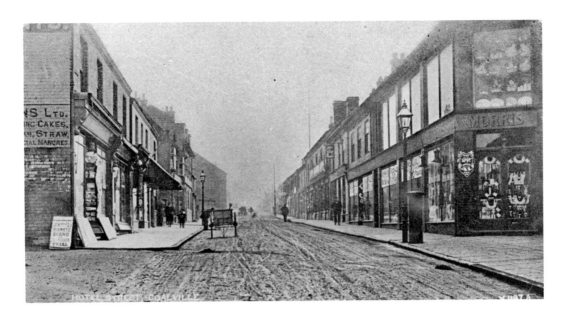

**Hotel Street, Looking East, *c.* 1915**

This section of Long Lane, separating Hugglescote to the right and Whitwick to the left, had been renamed Hotel Street after the Railway Hotel. The houses on the right were constructed in the early 1860s by the descendants of William Stenson, and had been extensively converted into shops by this time. On the left, a few of the buildings preceded the new development. It is noticeable that the road surfaces are rough, being surfaced with gypsum and rolled level, although they broke up in wet weather. All the buildings left stand empty and abandoned.

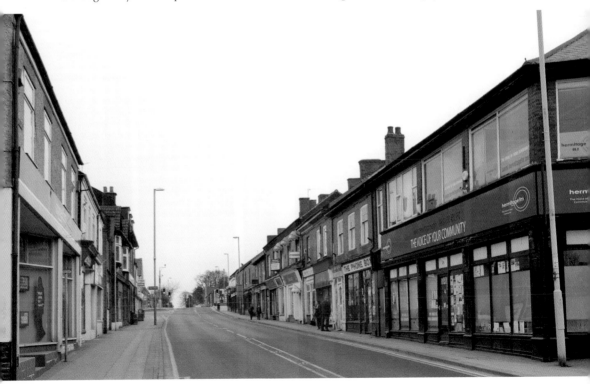

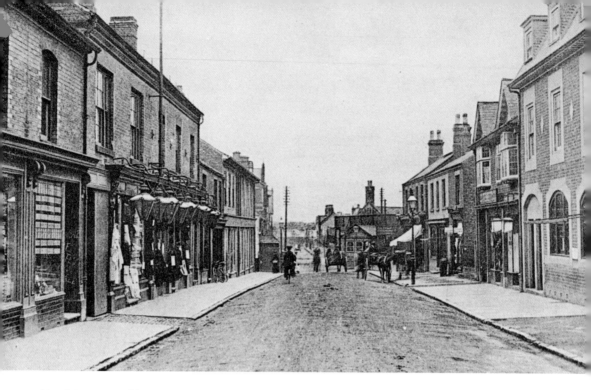

**Hotel Street, Looking West Towards the Station, 1905**
The large shop with exterior lighting on the left was owned by Hawthorns, who advertised their fashion garments as newly brought from London by train. The stationer's on the extreme left provided a service for intending emigrants to Canada. The tall building on the right initially housed the post office and then a printing works. It is now a sorry sight.

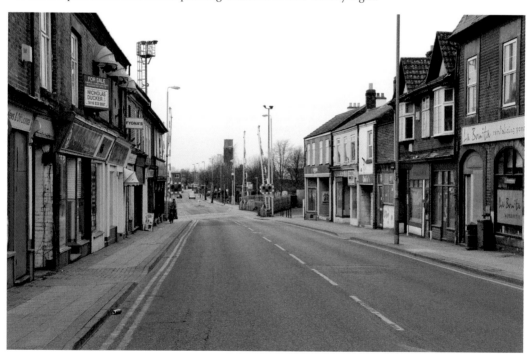

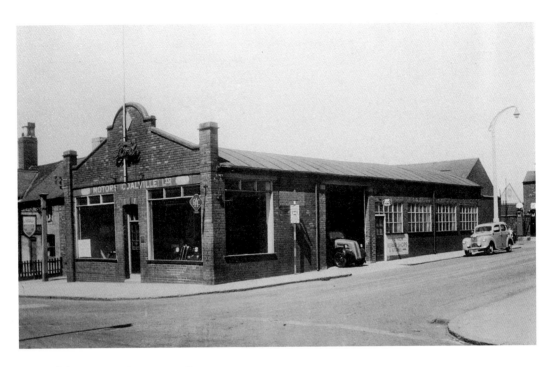

**Blithe & Sons Garage, 1948**

When the entrance of Whitwick Road was being widened, the motor car was gradually appearing on the streets. Henry Ford was mass-producing their range of vehicles based upon a standard chassis and set up agents to supply them. For example, in 1923 Blythes were advertising the 'Lincoln' range of about seven bodies, all with right-hand drive, particularly 'A redesigned touring car with one hood and a sloping windscreen' at a price of £128. A modern Ford distributer still occupies the garage. (*Whit*)

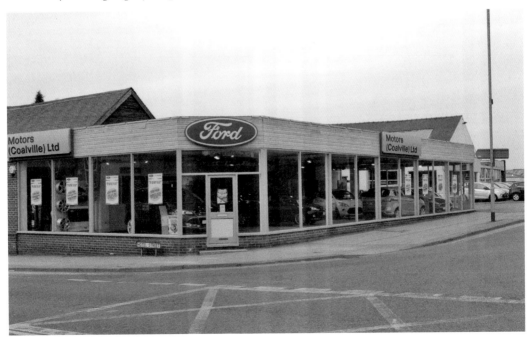

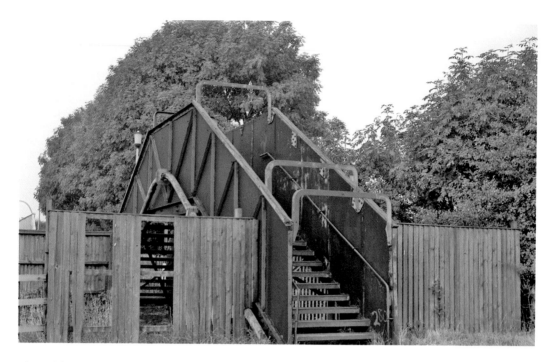

### The Bridges, 1995

The necessity of providing branch railways to Snibston and Whitwick Colliery, with connections to the main line, posed a real problem for the residents of and visitors to the town. At first, crossings could be made under control of signalmen, but as traffic increased, footbridges were built over both the main line and its branches to minimise delays for pedestrians. This bridge gained further notoriety in 1877 when a pedlar, Joseph Tugby, was murdered by three men in a robbery. They were hanged at Leicester. The iron bridges have been removed and the area has been tidied up with replacement steps leading to the car park of the precinct. (*Hugg*)

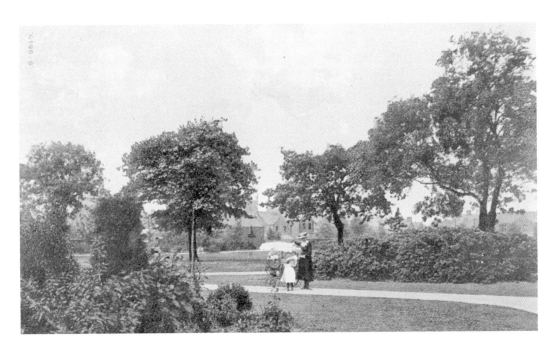

### Coalville Park, 1915

As the community began to take form, a number of local entrepreneurs sponsored a Coalville Athletics Club on ground they had purchased to the north of London Road. The club's performance grew and big sports meetings were organised, which attracted national athletes to encourage local men to improve their skills, and at the same time raised funds with the aim of providing a local park and recreation ground. In March 1899, after twenty years of work, the club donated the necessary land to the local council, but it took over a year to be opened. The park is well cared for by the district council. (*Whit*)

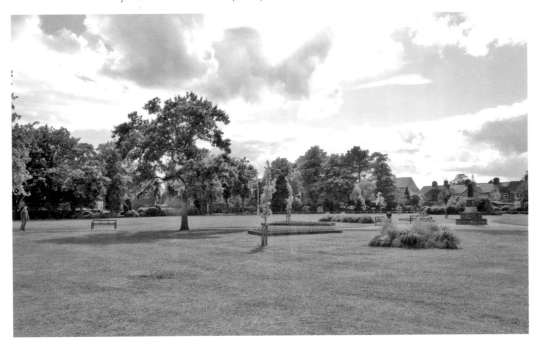

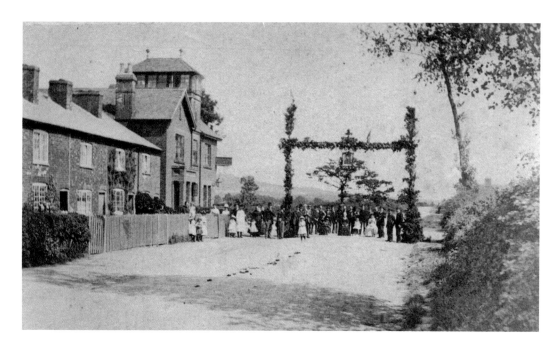

**Queen Victoria's Jubilee at the Fox & Goose Inn, 1887**
Prior to the birth of the town, there stood at the crossing of the Forest Road and Long Lane a small beerhouse called the St Crispens Arms, which offered refreshment to travellers from the forest. As Long Lane was developed, a new public house called the Fox and Goose Inn was built that also offered overnight accommodation. Alongside, there stood a row of cottages. As time passed, it became a favoured watering hole and one of its landlords had a glass lookout built on the roof to provide views of the forest and cricket matches being played on the Fox Field for his favoured guests. The site has recently been cleared to provide space for a well-designed, modern housing complex. (*Whit*)

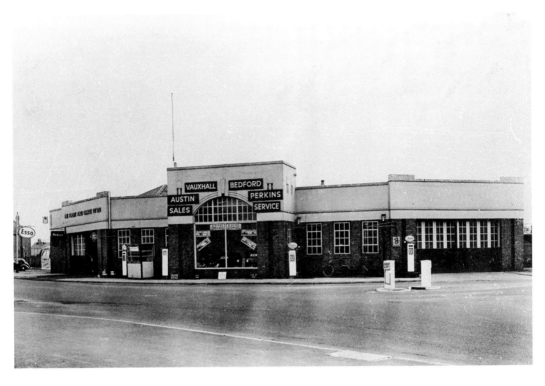

**Forest Road Garage, 1925**
This company was set up as agents selling Chevrolet cars – rather upmarket from Fords, at £238 for their touring model. A new range was promoted by the company each year, and it also sold a special range of tyres and supplied petrol to motorists. A housing development replaced the garage in the 1990s. (*Hugg*)

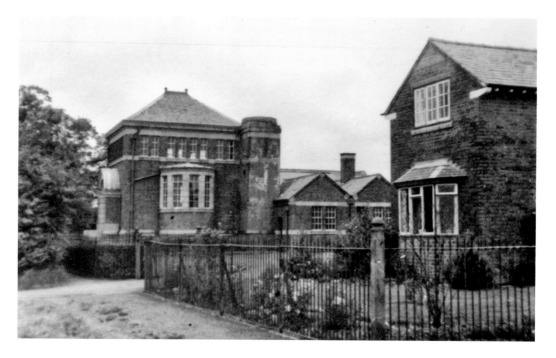

**Coalville Waterworks, c. 1930**

The works were constructed in 1903/04 and were augmented by water from Whitwick and Ellistown Collieries, taking water from the new red sandstone which overlaid the coal measures. The Broom Leys supply was sent to a 500,000 gallon reservoir near the Forest Rock Hotel, where it fed most of the district by gravity. Whitwick Colliery's supply fed directly to homes and Ellistown Colliery's was pumped into a concrete reservoir, 68 feet high. Modern developments now enclose the site of the demolished building. (*Whit*)

# The Development of Hugglescote Lane
## (Later Belvoir Road)

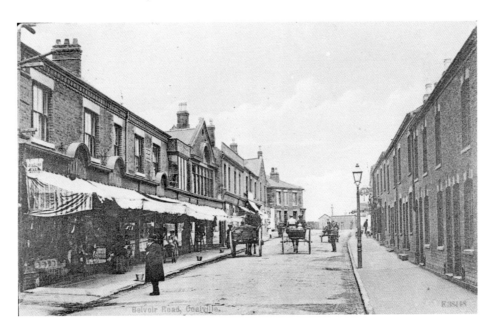

**Belvoir Road, c. 1900**

The shops on the left (*Snib*) were built progressively in the 1880s, the largest on the immediate left being Atlas House, owned by Pickworths, who made and sold bespoke gowns and millinery made by a large team of live-in dressmakers. On the right (*Hugg*), the houses were built by the descendants of William Stenson but had yet to be converted into shops. A number of the houses-cum-shops were demolished to make space for the precinct.

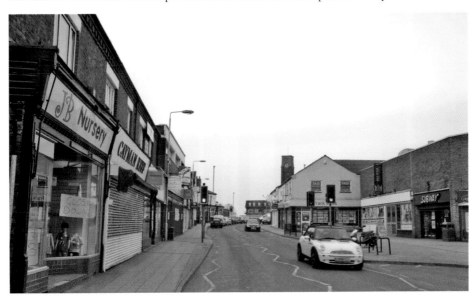

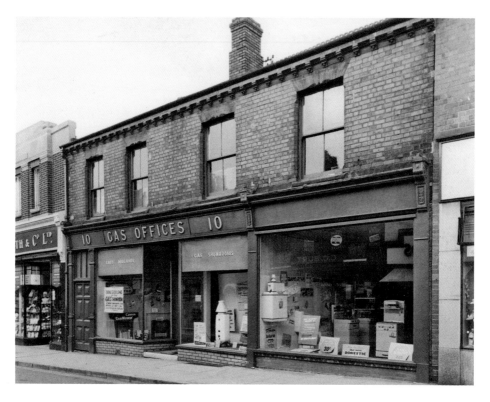

### Gas Office on Belvoir Road, 1950

In 1856, production of town gas was begun by the Whitwick and Coalville Gas Company Ltd, and this was distributed around the district to industrial and private customers as well as for lighting the streets. In the Gas Act of 1948, production and distribution was taken over by the East Midlands Gas Board, until coal gas was replaced by natural gas in 1967. The company began to sell and install appliances throughout the district. This part of the town now houses three major charity shops, several estate agent's and two betting offices.

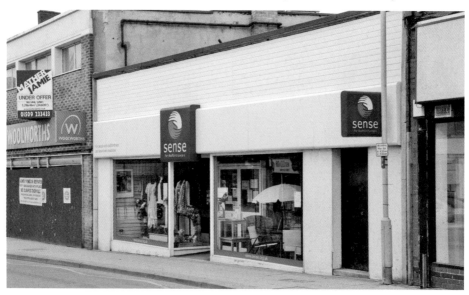

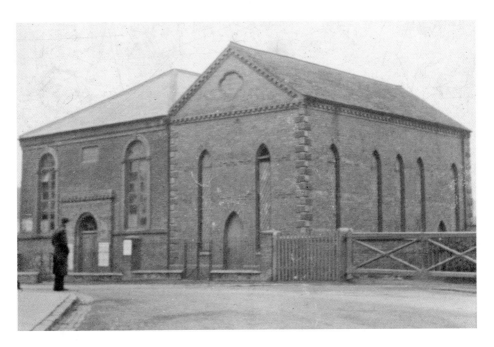

**The Primitive Methodist Church and School, Hugglescote Lane, *c.* 1900**

In the early days of the town, the Snibston School building was used for worship on Sundays by the Ashby Methodist circuit, and as the town grew the Methodists and Baptists provided the schooling for children of the colliers. However, in 1865, when George Smith had arrived and William Stenson's descendants were building houses, some land was given to erect a school for 120 children and a large church adjacent to the Snibston Colliery branch railway. In 1904, the worshippers moved to a new church in Marlborough Square and this building was remodelled for commercial use. (*Hugg*)

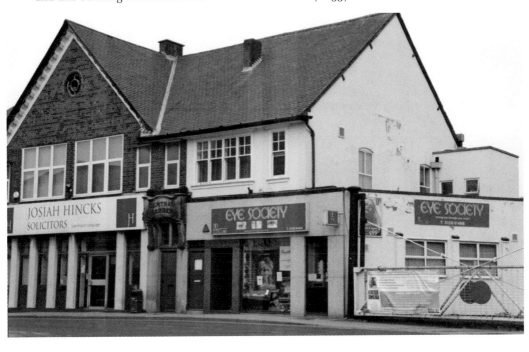

### The Central Field

Houses were built in the 1860s on the south side of Station Street and the west side of Hugglescote Lane, by descendants of William Stenson, on an open field, part of which was used for clay working by a local brickworks. The clay hole was filled with town waste by the end of the 1890s to provide space for visiting fairs and circuses. The field was later developed as the New Broadway shopping precinct, which has been remodelled several times prior to the current version known as the Belvoir Centre. (*Hugg*)

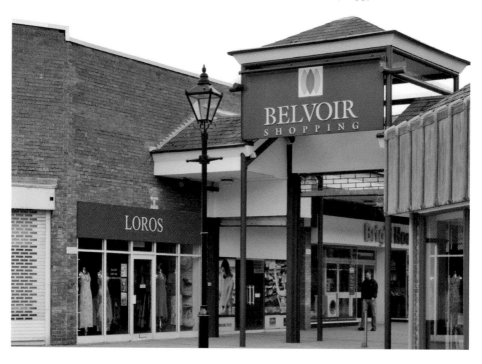

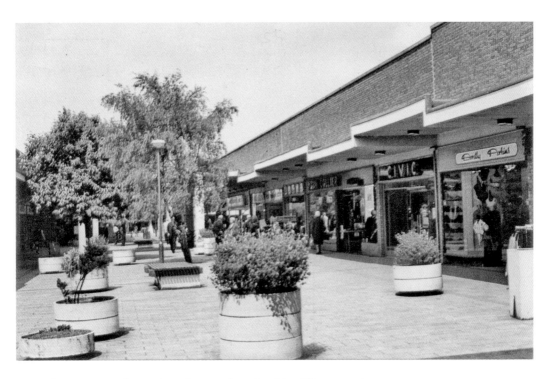

**The New Broadway Shopping Precinct, Looking West, c. 1963**
The precinct included branches of national traders, and was opened with great interest from local shoppers and with free car parking facilities. Trees and shrubs were introduced to provide greenery on the site and give a modern impression of what Coalville might become on its way to an improved future. Finance companies, which have successively owned it, have attempted improvements, but many of the shops have been vacant for some time and choice is now very limited. (*Hugg*)

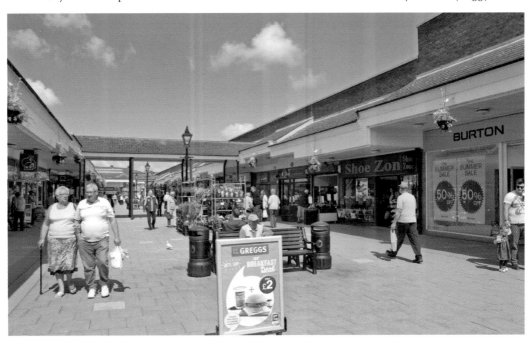

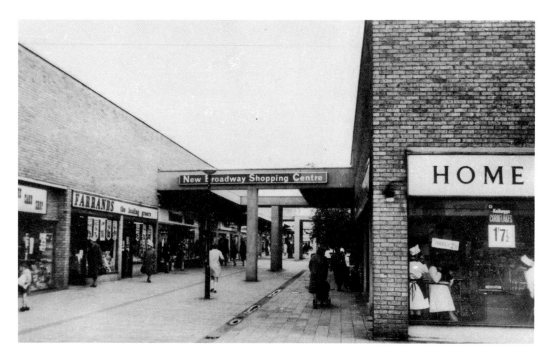

## The Entrance to the Precinct, Looking East, 1965

This represents the view seen after shops were demolished to build the shopping centre (*No. 59, above*). Some of the planting has been removed, but the centre was still busy catering for local people's needs as well as more distant shoppers making use of the free car park. The car park is now poorly used, owing to the lack of variety of available shops and the cost of parking charges imposed by the council. (*Hugg*)

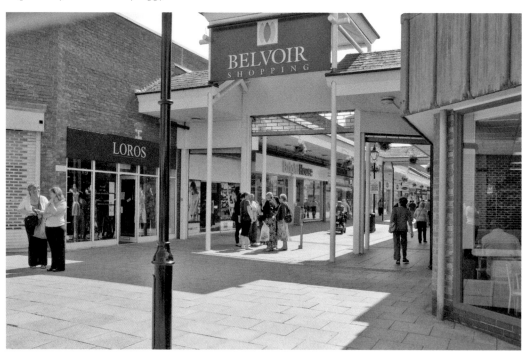

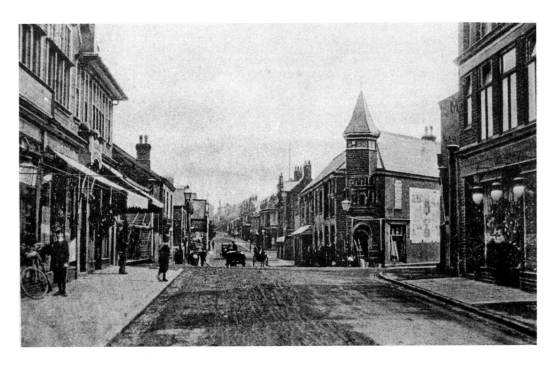

**Snibston Colliery Branch Railway Crossing, *c.* 1950**
Coalville was for a long time bedevilled by three gated railway road crossings, two for the Midland Railway and one for its Snibston Colliery branch. The shunting of wagons to and fro interfered with the movement of traffic through the town for considerable parts of the day. Mantle Lane gate, one of the original three crossings, was replaced by an underpass in the early 1900s. The rails and crossing gates remain, but the only trains that run are those between the crossing gates and the Discovery Museum. (*Hugg*)

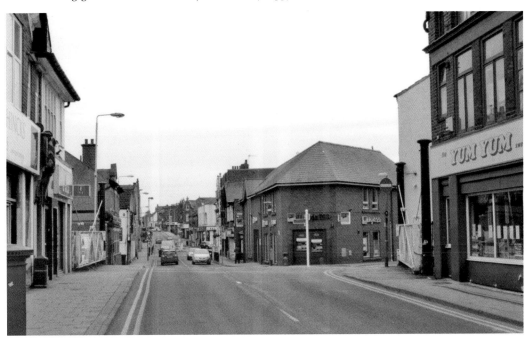

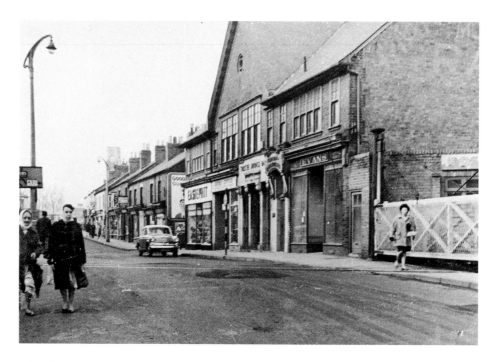

**Oliver's Crossing, c. 1910**

The branch railway to the Snibston No. 2 Colliery, built in 1833, crossed Hugglescote Lane here. For a number of years, the gates were controlled by Oliver Robinson, who had been injured in the pit in the 1880s and was given 'light duties'. His family moved from Nottinghamshire to Snibston Colliery before 1840, where his father and two brothers found work. Oliver proved to be quite a character; he died in 1892, still working at the age of seventy.

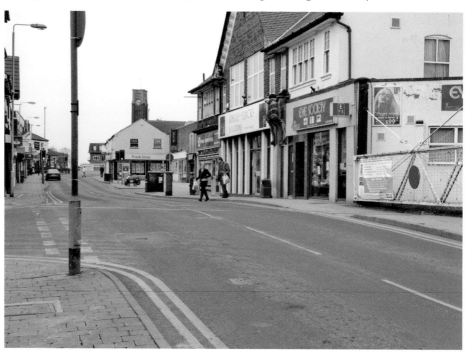

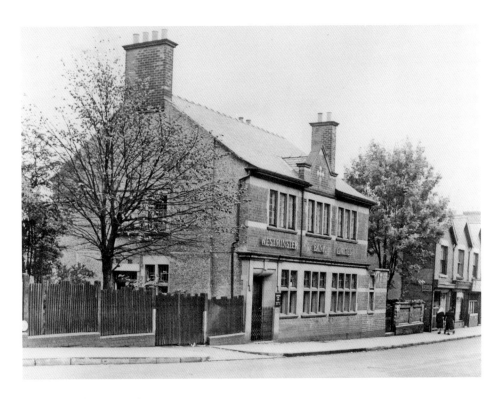

### The Westminster Bank

In the late 1890s, this site had a grocery shop and adjoining house, but as trade increased it was replaced by a branch of the Nottingham and Nottinghamshire Bank in 1905. The premises was purchased in 1913, and traded so well that under a merger it became the Westminster Bank in the 1920s and the National Westminster Bank in 1970. NatWest still serves the community. (*Hugg*)

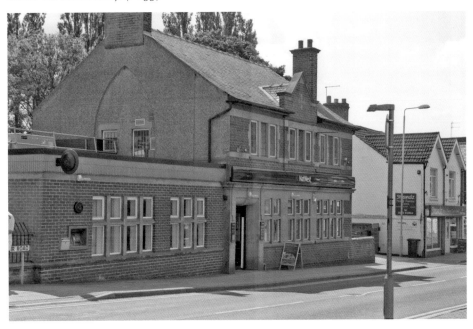

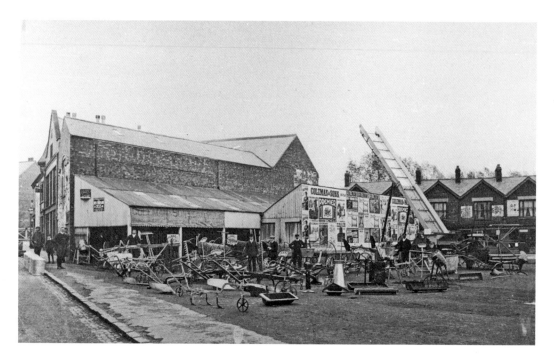

**Coleman's Range of Agricultural Equipment, 1920**

William Coleman came to Coalville from Loughborough to set up an ironmongery business in the Newmarket, which was being relocated for a second time and development of which spread into the Snibston area. The business flourished, being them being chosen as 'Wholesale and Retail distributers of Refined American Petroleum' in 1904. William's sons expanded the business by providing a choice of '25 dining and drawing room suites, 15 ovens, 100 bedsteads and 30 bedroom suites'. They also acted as agents for agricultural equipment. Lloyds TSB is now located on the site. (*Snib*)

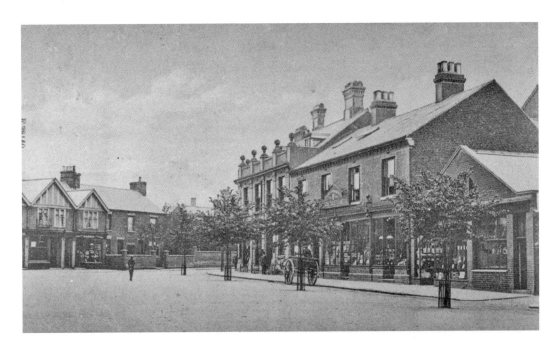

## Marlborough Square

The development of the Snibston sector of the town took a major step forward when a large portion of the Whiteleys' fields were developed for the resiting of a large cattle market. The market was resited on the Newmarket, which was equipped with a wide range of cattle pens for market day. It was flanked by the Public Hall and offered good opportunities to arrange large town gatherings, like the one for Queen Victoria's Golden Jubilee. Coalville Co-op developed many of the premises here for its customers, but its business declined and in 2013 all the shops including its departmental store closed down. (*Snib*)

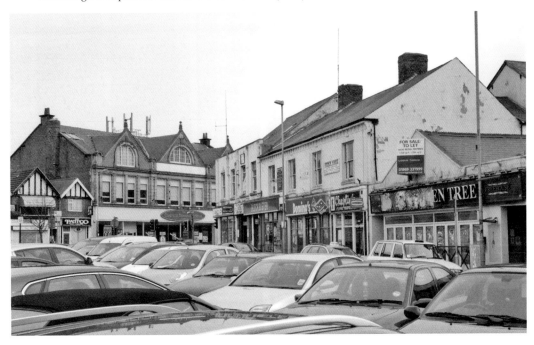

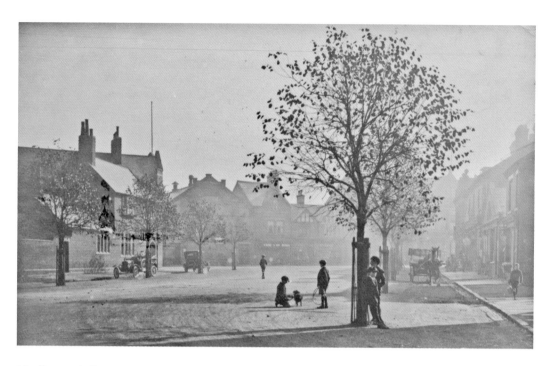

### Marlborough Square, 1910

This picture shows how the Newmarket was intended to be, following the move of the cattle market to allow further development of the Snibston estate. A good open area, which was tree lined, was ruined by the intrusion of the motor car and bus. What a joy it would be to return it to this state! It eventually provided a location for the business centre of the Coalville Working Mens' Cooperative Society. Surrounding it were three cinemas, a bank, a roller rink, a Methodist church and the Liberal Club for large functions. (*Snib*)

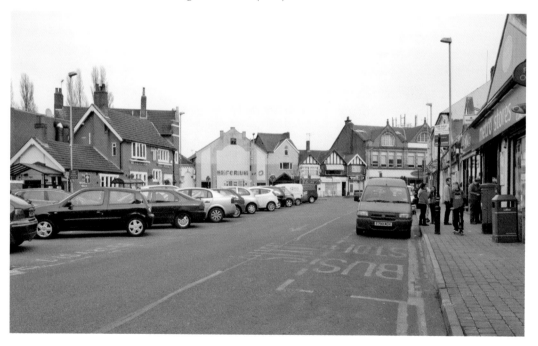

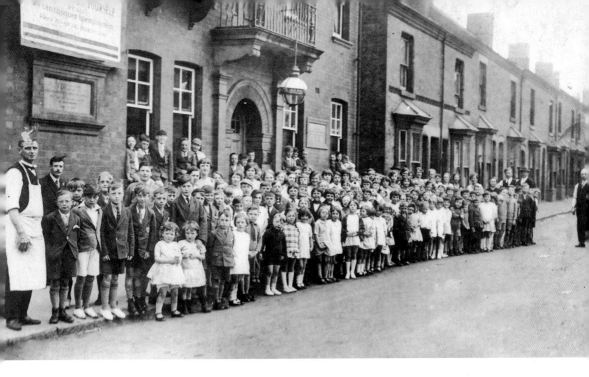

### The Liberal Club, *c.* 1939

A strongly supported Liberal Club was built in Marlborough Square at the time of the removal of the cattle market from the Newmarket site. Built alongside was the Progressive Hall that was able to accommodate large events and functions, which would previously have been held in the Public Hall before its conversion to the Electric Theatre. The Rex, a luxury cinema, was constructed a few doors away and all three still occupy the site.

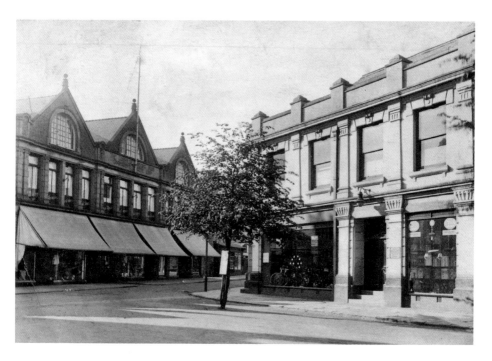

### Coalville Working Mens' Cooperative Society, 1940

Created at a time of depression, the society opened for business in June 1882 in a small cottage with a membership of around fifty, which grew to 800 by 1892 with around £350 a week trade. It paid a dividend of 2/7d in the pound when it moved to larger premises in the Newmarket. The society continued to prosper, and during the early days of the Battle of the Somme in 1916 the society opened its central premises to supply drapery, boots, tailoring, outfitting mantles and millinery. In 1930, it had 13,300 members, producing sales of around £9,000 a week and showing a gross profit of £55,358. It had a share capital of £39,9970 with £282,830 worth of investments. The central stores closed this year. (*Hugg*)

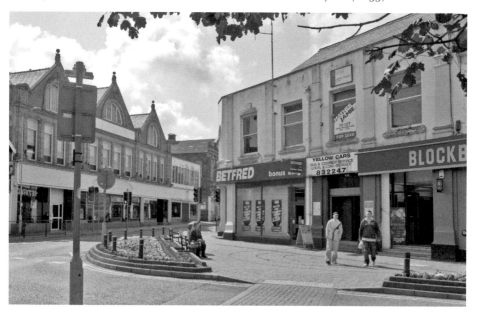

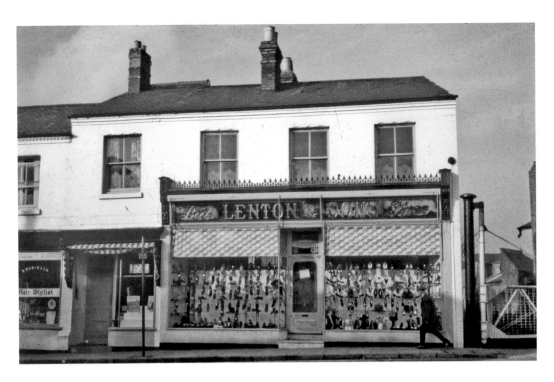

### Lenton's Boot and Shoe Shop, 1964

This was one of the new shops set up in a scheme to develop the Snibston side of Hugglescote Lane in the 1880s. John Lenton located his establishment on Jackson Street to provide shoes for the middle classes, and was proud to note in 1895 that his was the first shop to be illuminated by electricity, generated by an engine in the cellar of the shop. The shop survived for around 125 years and is now an Italian restaurant. (*Snib*)

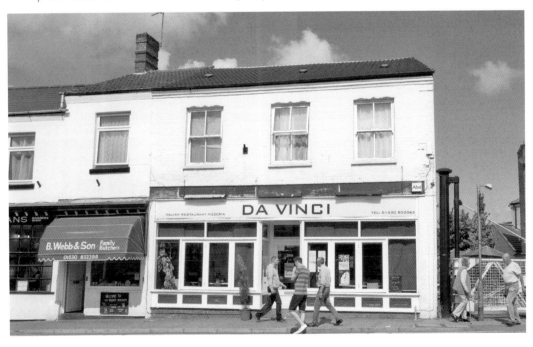

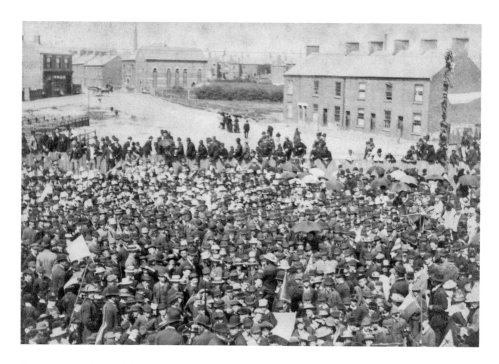

### Queen Victoria's Golden Jubilee, 1887

A public meeting was arranged in the Newmarket on the occasion of the event, and people sat on the fences of the cattle pens to get a better view. The row of cottages on the right was known as 'Bug and Flea Row' and the old Primitive Methodist church can be seen next to Oliver's crossing. Lenton's shop is visible at the top left of the photograph. The area now holds The Monkey Walk pub. (*Snib*)

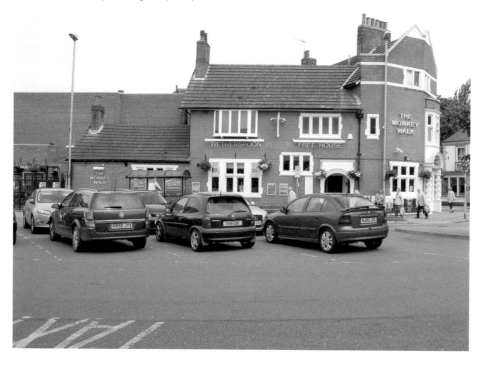

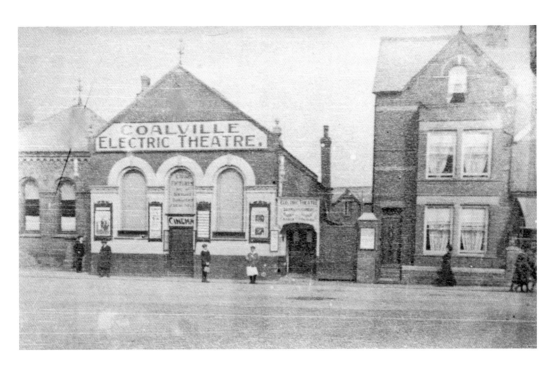

### Coalville Electric Theatre, 1912
The cinema came to Coalville in 1910, when Biograph shows were introduced in the old Public Hall, which was converted into the Coalville Electric Theatre by Mr Johnson from London. Silent moving films, accompanied by a pianist, entertained a growing audience, but in 1920 the business was taken over by Mr Deeming, who renamed it the 'Grand Cinema'. The Emporium now hosts a nationally renowned nightclub. (*Hugg*)

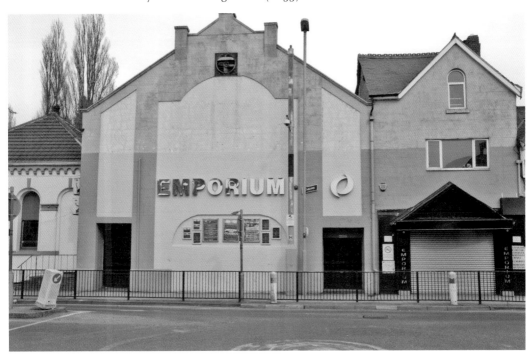

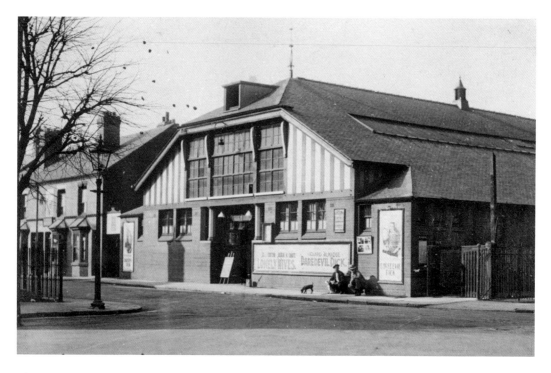

## The Olympia, 1920

The Coalville Olympia Company, an organisation of local businessmen set up to provide all entertainment in the town, chose the erection of The Olympia in 1909 – a roller rink that could be adapted as a theatre – as one of their first developments. It was later used as a second cinema until 1933 when it was demolished to make way for the Regal cinema, which was built in the Art Nouveau style. The building now houses a bingo club. (*Snib*)

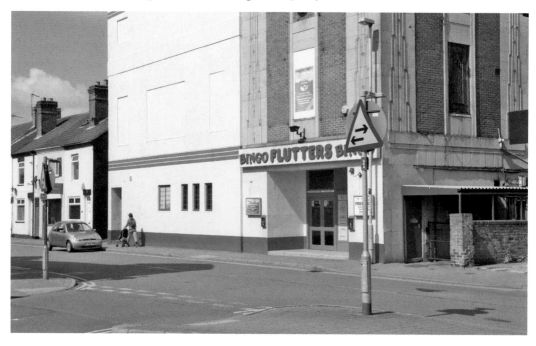

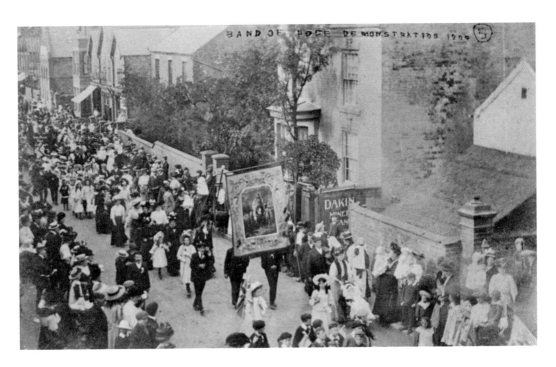

### Band of Hope March on Hugglescote Lane, 1909

The religious tone in the new town was originally set by the many Nonconformist chapels, which spoke out strongly against the evils of drink. A visitor from London was moved to write to the *Coalville Times* stating he was impressed by the lack of drunkenness in the local community. In 1909, there was a demonstration by 1,000 supporters of the Band of Hope in a march to visit all the town pubs. Here the parade has just left the Engineers Arms pub and was passing a mineral water bottling plant at Wilkins farm. The farm was later purchased by the Co-op to enable further developments. (*Hugg*)

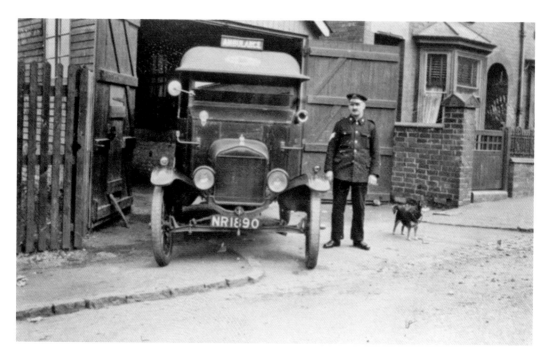

**Ambulance Station, James Street, 1927**
People injured in local pits, brickyards and factories faced a long trip to hospital in Leicester, unless it happened to coincide with a suitable passenger train service. First horse-powered carts then motor lorries provided a very uncomfortable transfer, and it was not until December 1923 that fundraising began to purchase ambulances, which were kept in James Street. (*Snib*)

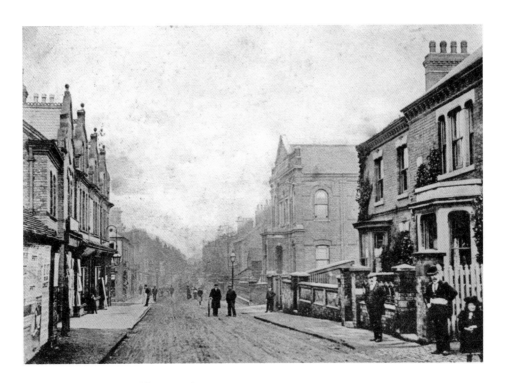

## Hugglescote Lane Looking North, 1915

This part of Coalville was known as Whiteleys, after the farm which stood in Snibston parish to the immediate left. The area on the right was in the Hugglescote sector, and had been extensively developed by thenconstruction of side streets to house waves of newcomers in the 1860s and 1870s. The Wesleyan Methodist church and school was built in 1881 to meet the needs of the new occupants of the Gutteridge estate.

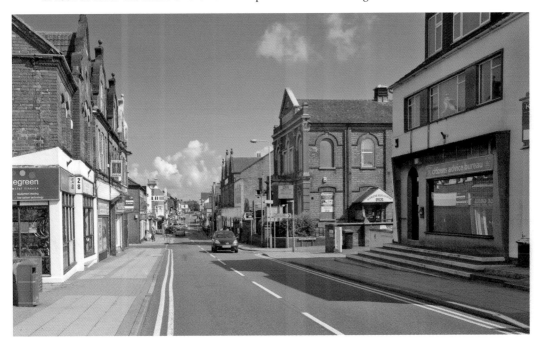

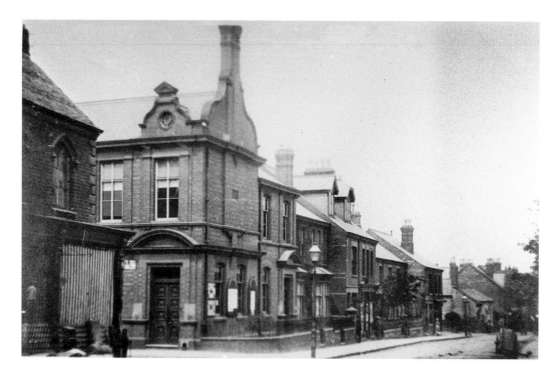

## Police Station and Magistrates Court

By the mid-1890s, when local government was being reviewed, there was pressure to separate Whitwick from Coalville, but the evidence presented enabled Coalville to gain Urban District, Local Board and Parish status. The district police station and the magistrates' court was moved from Ashby. Building the police station began alongside the development of the Gutteridge estate, and the law court had its first sitting on 13 July 1894. The police station was moved to Ashby Road around ten years ago, and the court has been closed, since moving to Hinckley. It is now the premises of a funeral contractor. (*Snib*)

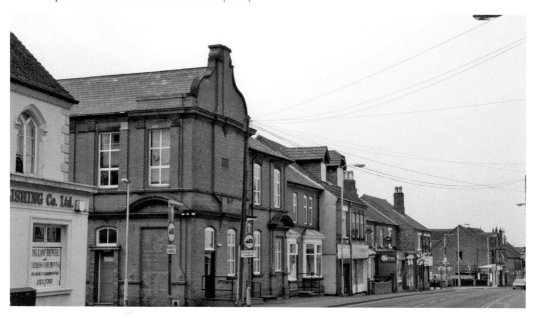

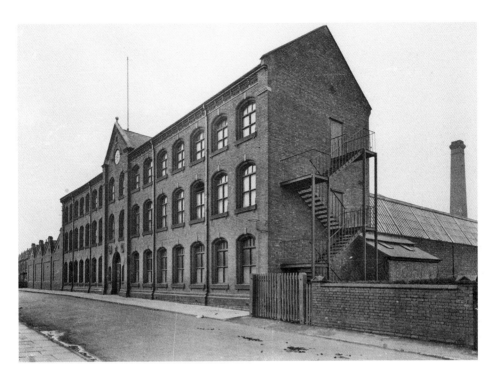

**Burgess & Sons Factory on Hugglescote Lane, 1945**

In the brickyards, women and children worked in appalling conditions to augment the family budget since they were outside the control of the Factory Acts. George Smith of Coalville, manager of the Whitwick Colliery Brick Company, fought a personal and national campaign to persuade Parliament to pass a Brickyard Act in 1877, which excluded women and children and initiated introduction of a number of new industries to take advantage of this labour pool. In 1872, T. & J. Jones built this narrow elastic web factory and expanded it to employ some 400 women very succesfully from 1901. The building was knocked down in the 1990s and replaced with housing. (*Snib*)

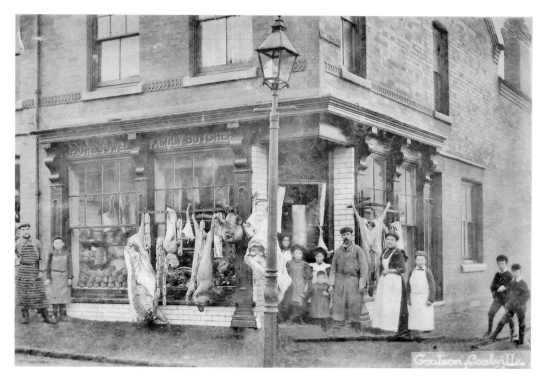

**Cresswell's Butcher's, *c.* 1896**
George and Caroline Cresswell had come from Derbyshire in 1886 to open a pork butcher's shop, with its own slaughterhouse behind. It provided fresh meat to the growing number of families finding employment in the mines, on the railways and in the elastic web factory nearby. The new occupants are involved in the digital industry. (*Hugg*)

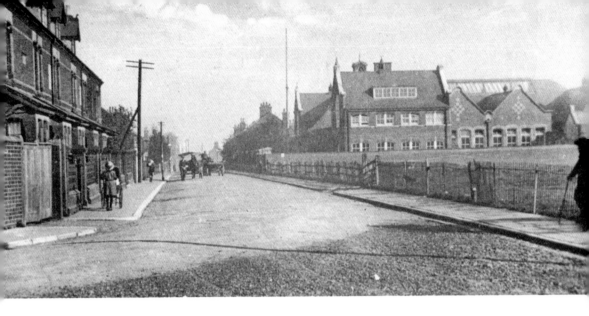

**Bridge Road, 1912**
This road was built following the line of an ancient footpath across open fields leading from Hugglescote to Whitwick. Housing development began around 1890, and the secondary school was built in 1908. This was subsumed into Coalville Mining and Technical College, later renamed Stephenson College. (*Hugg*)

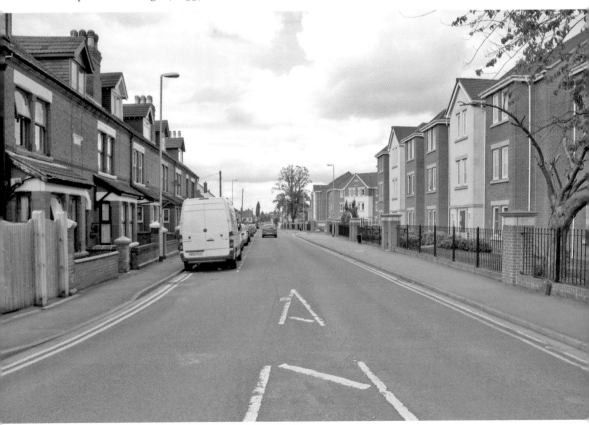

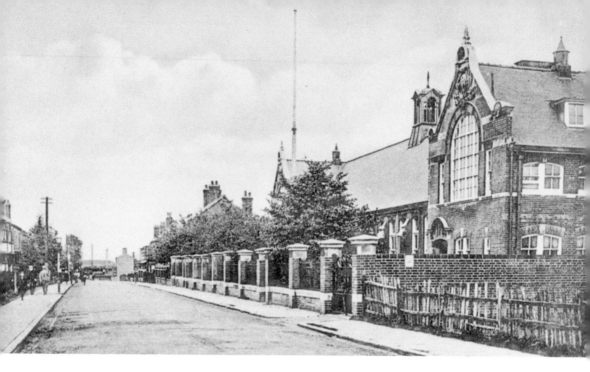

**Bridge Road School, 1930**

Bridge Road New Council School was opened in 1908 to provide secondary provision for teenage children. A sound education in vocational studies was available for 600 children and for evening class students. In 1934, primary and junior schools were built on the same campus. When Stephenson College was moved to the outskirts of town, the buildings were demolished to provide space for housing. (*Hugg*)

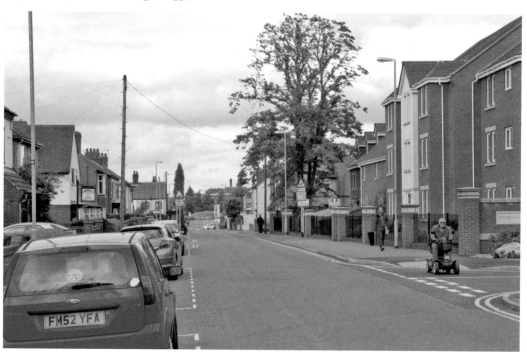

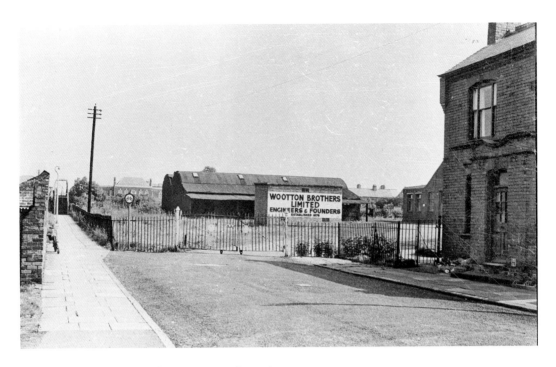

## Wootton Bros Foundry & Iron Works, 1960

Attracted by the increasing need for specialist engineering supplies to the town's mining, railways and brick making industries, the Wootton Brothers came from Loughborough in 1876 to produce forged and cast components. Such was the quality of their work that they soon became specialists in providing modular brickworks equipment and 'Charnwood Steam engines'. They gained a worldwide reputation, but the company ceased trading in the 1980s and the site was developed by a supermarket. (*Hugg*)

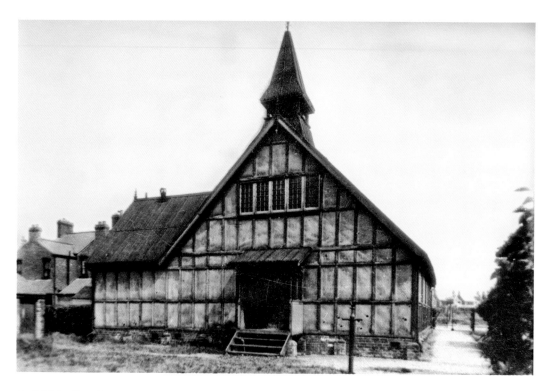

## St Faith's Church

As the town continued to expand, James Gutteridge and others invested in the building of a housing estate in the Snibston fields. Churches were erected to serve the new community. The previous, tiny church of St Mary at Snibston was of Saxon origin, and St Faith's was erected in competition with a new Roman Catholic church in 1900. The style of building was used in the American West, and comprised a wooden framework on which wire netting was fixed, and into which gypsum plaster panels were cast. The church was later developed as St James, but has recently closed. (*Snib*)

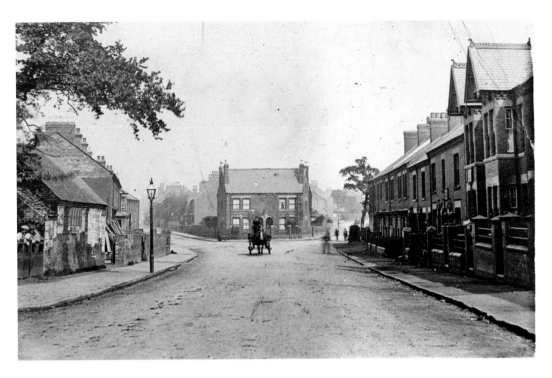

**The Junction of North Street and Forest Road, 1910**

North Street, the road leading off to the left, was the ancient track that led to Whitwick and to the right Forest Road went to Charnwood Forest. After the early growth in the new settlement, most of the housing developments had taken place in the Hugglescote sector to accommodate incoming workers for new industries. This scene is little changed except for traffic. (*Hugg*)

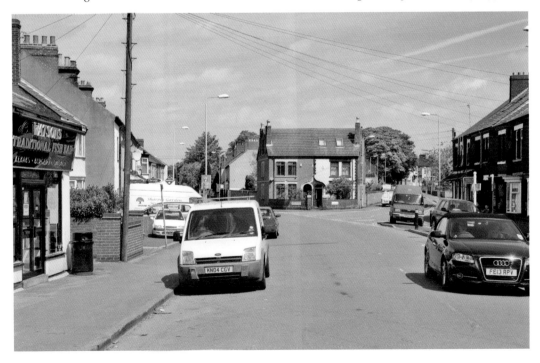

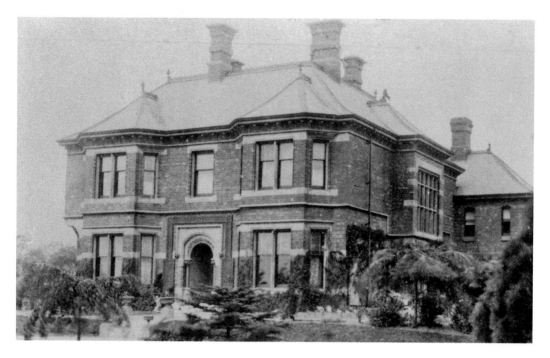

**The Scotlands House, 1920**

In 1875, The Scotlands was built for J. P. White, managing director of the South Leicestershire Colliery Company by Oliver Lindley, a local stonemason and prominent architect who had designed many prestige buildings in London. On his death, the house and estate was leased by a convent of nuns and then purchased by a Surgeon of Leicester Royal Infirmary. A housing development was built on the site in 1939 by William Davis as The Scotlands Estate, which still survives. (*Hugg*)

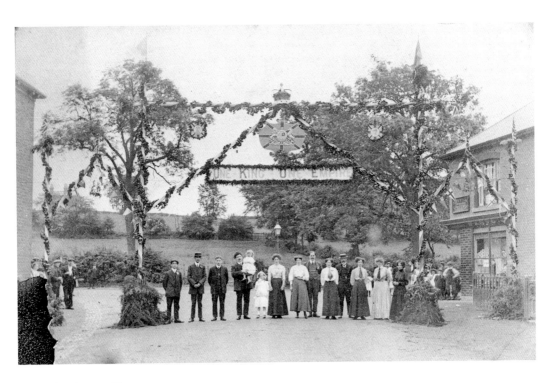

### The Corner Pin

The public house at the junction of The Green and Meadow Lane, on the southern outskirts of Coalville urban district, was pictured here dressed up for the coronation of King George V. The road on which the photographer was standing was Meadow Lane, later renamed Tween Town, which led to the twelfth-century Donington Manor. The scene is little changed today. (*Hugg*)

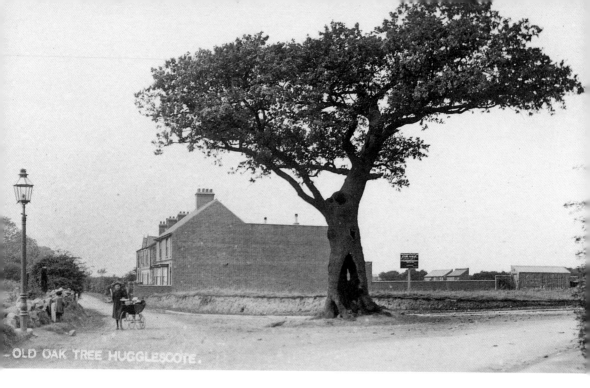

**The Old Oak Tree, 1920**

By the side of the Ashby to Burton stood an oak tree planted on the border between Hugglescote and Snibston, which was around 800 years old and was hollow with age. Local tradition claimed that King Charles had hidden in its branches. (*Hugg*)

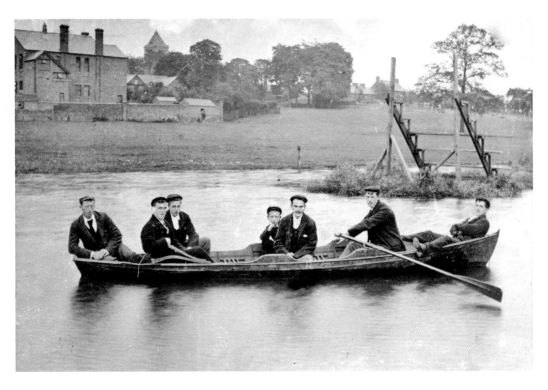

**The Mill Dam, 1910**
There had been a watermill in Hugglescote since the thirteenth century and the last recorded one, owned by a Mr Lander, was built at the end of the 1700s. It had a large mill dam, which was used for water sports and boating. The mill survived until the 1930s, when the millpond was filled with town rubbish and levelled to make a recreation field. (*Hugg*)

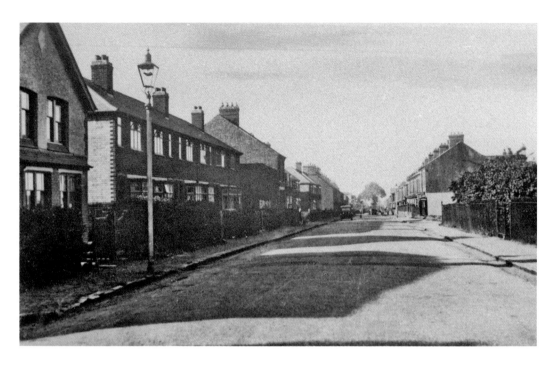

**Highfields Street, 1937**

When James Gutteridge planned his estate in the open fields of Snibston and Hugglescote he may not have considered how many houses would eventually be built, or the extent to which Hugglescote would become joined with Coalville with the building of this street, Crescent Road, Fairfield Road, Breach Road and Central Road. It is fair to say the major extension of the early town was in this sector. The view today is little changed, but there are plans ahead for further extensions. (*Snib*)

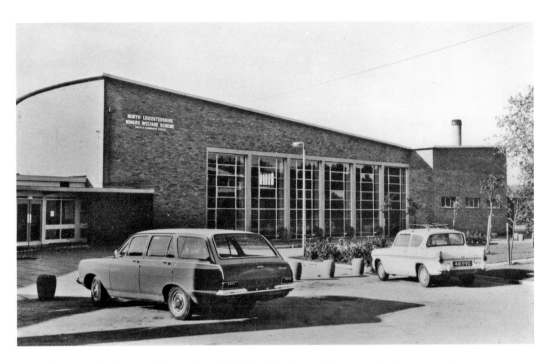

**The North Leicestershire Miners' Welfare Youth and Community Centre, 1980**

The centre, costing £125,000, was opened in September 1965 by the Rt Hon. H. W. Bowden MP as an amalgamation of Snibston Mine Workers' Scheme and Whitwick Colliery Sport and Social Club, and backed by CISWO. It offered sport and leisure facilities in a futuristic designed building seating 950, adjacent to a County quality cricket ground. It was gutted by a fire in the 1980s and never replaced. Many residents of Coalville now commute to work some distance away, and require the replacement of industrial sites with housing. (*Snib*)

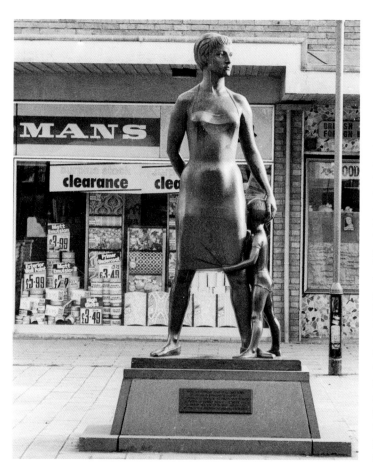

**Mother and Child Statue, 1963**
This statue was commissioned by Costain property developers in 1963 as a centrepiece for their new precinct project. It was designed by Welsh sculptor John Rydon Thomas, and features a woman holding a string shopping bag containing lumps of coal, a bobbin, books and a baby doll, all symbolic of Coalville's industry. It was removed by the then developers and abandoned in 1986, but thankfully rescued by the local council to stand proudly by the library on High Street. (*Hugg*)

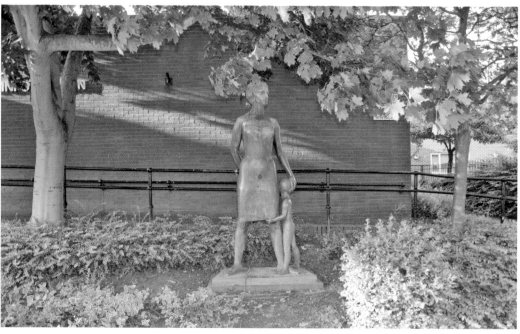

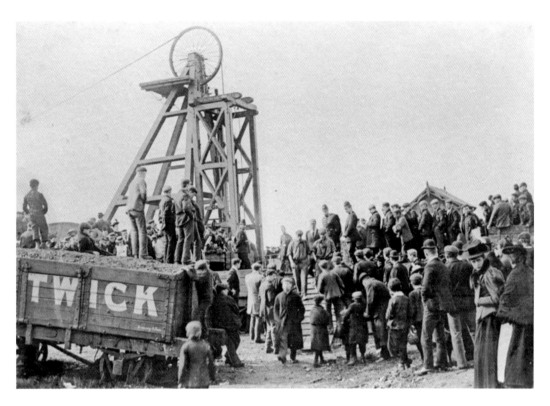

### Whitwick Colliery Disaster, 1898

On 19 October, an underground fire caused the death of thirty-five miners working on the night shift in Pit No. 5. Local miners formed a rescue team, but the heat and noxious gases prevented them reaching some of the lost men until several days later. A large crowd of relatives and friends gathered awaiting news, but further victims were not found for several months and some still remained entombed. A Garden of Remembrance has been installed, marking the position of the pit shaft involved in the fatal event. (*Whit*)

**The Queens Head Inn, 1950**

As the coal industry developed, Snibston Colliery Company opened their third mine in Thornborough, which provided further jobs for incoming miners. A little settlement opened up near the pit, encouraging the development of brick and pipe making on Mantle Lane. The inn was opened by a local butcher as part of a flourishing business enterprise. The site of the inn with its slaughterhouse became a garage in the 1970s. (*Swan*)

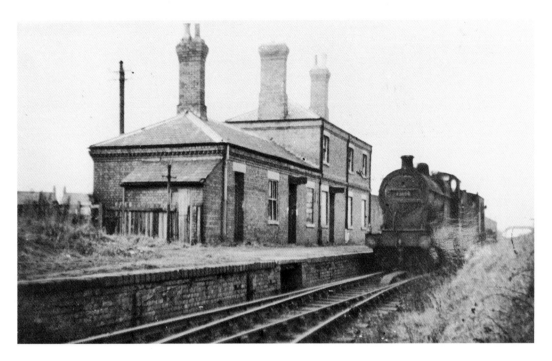

**Coalville East Station, 1950**

In 1883, a second railway was introduced into the town by a partnership of the Midland Railway Company and the London North Western Railway Company. The Charnwood Forest Railway, a branch from the Ashby and Nuneaton joint line at Shackerstone junction, connected the town with Loughborough on a single track crossing through stations at Whitwick, Thringstone, Gracedieu, Shepshed to Loughborough. It had branches to Whitwick Granite Quarry and Whitwick Colliery. The line was abandoned in the 1950s. (*Whit*)

# Acknowledgements

In 1983, a week long exhibition was arranged in celebration of the birth of Coalville 150 years before. The exhibition focused on the history of coal mining and transport in the four villages and illustrated the growth of the interesting Victorian town by maps, stories and around 400 photographs donated by local people.

We undertook to copy and return these photographs after the event but most collectors were happy to donate them to a Coalville 150 Archive if we continued collecting them and made them available for public viewing. A few donors set conditions to their loan which we strictly observe.

In the 30 years since that event our archive count has risen to over 2,000 and we display the pictures to the public by publishing themed booklets, giving illustrative talks and setting up exhibitions.

We would like to acknowledge the support of all those individuals who have made donations to the archive, and particularly to the dedicated staff of both our local library and Snibston Discovery Museum for their support and encouragement, and especially to Linda Harrison for her tireless work in planning and proofreading.

The abbreviation in italics after the caption refers to the parish that the area pictured was originally part of.

Please note that wherever possible we have tried to contact the copyright holders of the photographs for permission to use: however, in many cases it has been impossible. If you are the copyright holder of any of the pictures used in this book please accept our apologies. If you contact us via the publisher we will ensure that the situation is remedied in any future editions.